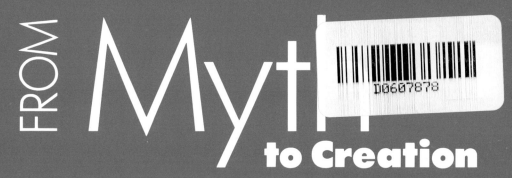

FROM Myth to Creation

Art from Amazonian Ecuador

Dorothea S. Whitten and
Norman E. Whitten, Jr.

University of Illinois Press
Urbana and Chicago

Cover:
Effigy jar. Rosaura Hualinga,
Río Llushín

This effigy jar, called *sicuanga manga*, toucan jar, was made specifically for the ethnic-arts market by Rosaura Hualinga. The face represents Nungwi, spirit master of garden soil and pottery clay. The motif is that of the *charapa*, seat of power of the spirit master of water, Sungui.

©1988 by the Board of Trustees of the
University of Illinois
Manufactured in the
United States of America
P 5 4 3 2 1

Whitten, Dorothea S.,
 From myth to creation.

 Bibliography: p.
 1. Canelos Indians – Religion and
mythology – Exhibitions. 2. Canelos Indians –
Art – Exhibitions. 3. Indians of South America –
Ecuador – Religion and mythology – Exhi-
bitions. 4. Indians of South America –
Ecuador – Art – Exhibitions. 5. Krannert Art
Museum – Exhibitions. I. Whitten, Norman E.
II. Krannert Art Museum. III. Title
F3722.1.C23W44 1988 704'.0398 87-38091
ISBN 0-252-06020-2

Contents

To the Canelos Quichua,
Past, Present, and Future

¡Ashca pagracha alli runagunata;
Unaimandata callarirucugunamanda;
Cunalla cambaj yachana cuti causanaun!

Preface

Canelos Quichua people regard the imagery embodied in their traditional ceramics and in their ethnic art as an enduring part of their mythology and legend, as something to be transmitted to other cultures via the objects of creativity themselves. Their own lasting imagery intensifies and even flourishes as appreciation from others occurs. The exhibition for which this book was prepared is ephemeral. It brings together examples of indigenous creativity, presented from the viewpoint of the creators. Eventually, the objects displayed are returned to various locations to be stored and studied by scholars specializing in subjects ranging from ceramic engineering to social structure, from art and art history to ecology, from religion to politics.

The purpose of this book is to provide something that will endure, something to spark continued appreciation by those who may never visit the Canelos Quichua and also for those fortunate enough to know them. Specificity of cultural context is this book's essence. During the exhibition at the Krannert Art Museum, a symposium will be held on the general subject of *Imagery and Creativity*. The resulting book, which should be available in 1989, complements this one by providing a comparative review of ethnoaesthetics in the study of culture and by exploring the multifaceted issues raised by the search to understand how humans draw upon their imagination and perception to create beauty and meaning in their ongoing lives.

Acknowledgments

Book and Exhibition Text
Dorothea S. Whitten and Norman E. Whitten, Jr.

Book Design
Ann Tyler and Renate Gokl

Black-and-White Photography
David Minor
Eduardo Quintana
Dean Meador

Color Photography
Dorothea S. Whitten
Norman E. Whitten, Jr.
Wilmer Zehr

Drawings
Alfonso Chango

Editing
Theresa L. Sears

Exhibition Design
Dorothea S. Whitten and Norman E. Whitten, Jr.
Stephen S. Prokopoff
Sarah Handler
Bruce Bowman

Exhibition Preparators
Bruce Bowman
Jeff Everett

Exhibition Music
Clara Santi Simbaña (songs)
Abraham Chango (transverse flute)
Estanico Santi (bird-bone flute)
Dario Machoa (song)
the late Pedro Mamallacta (shaman's song)
Family of Abraham Chango and Clara Santi (songs)

Stereo Recording
Norman E. Whitten, Jr.
Neelon Crawford

Loans for the Exhibition
Dorothea S. Whitten and Norman E. Whitten, Jr.
Joe Brenner
César Abad
Museos del Banco Central del Ecuador

Research Assistance
Diego Quiroga
Isabel Pérez

Special Coordination
María del Carmen Molestina
Sarah Handler
Dee Robbins

Special Facilities
Thomas Uzzell

Special Consultants
Mary-Elizabeth Reeve
Marcelo Santi Simbaña
Alfonso Chango
Luzmila Salazar
Balvina Santi Vargas
Segundo Vargas Dagua
Apacha Vargas
Esthela Dagua
Rubén Santi
Delicia Dagua
René Santi
Clara Santi Simbaña
Abraham Chango
Camilo Santi Simbaña
the late Soledad Vargas
the late Virgilio Santi
the late Gonzalo Vargas

Sponsors of the Exhibition, Symposium, and Books
Sacha Runa Research Foundation, Urbana
University of Illinois at Urbana-Champaign:
 Krannert Art Museum
 Natural History Museum
 University of Illinois Press
 Department of Anthropology
 Center for Latin American and
 Caribbean Studies

Support of the Exhibition, Symposium, and Books
Sacha Runa Research Foundation, Urbana
University of Illinois at Urbana-Champaign:
 Afro-American Program
 Department of Anthropology
 School of Art and Design
 Program on Ancient Technologies and
 Archaeological Materials (ATAM)
 Materials Research (Ceramic Engineering)
 Department of Geography
 Krannert Art Museum
 Center for Latin American and
 Caribbean Studies
 School of Music (Department of
 Musicology)
 Natural History Museum
 Department of Political Science
 Program in Religious Studies
 University of Illinois Press
 Department of Sociology
 Department of Spanish, Italian, and
 Portuguese
 Program of Women in International
 Development
 Lorado Taft Fund (School of Architecture)
 School of Humanities
 George A. Miller Endowment Committee
 College of Liberal Arts and Sciences
 Office of the Chancellor

**Support for Research Development of the
Exhibition, Symposium, and Books**
University of Illinois at Urbana-Champaign:
 Research Board
 Program in International Studies
Sacha Runa Research Foundation, Urbana
Museos del Banco Central del Ecuador
Instituto Nacional del Patrimonio Cultural
 del Ecuador
Comuna San Jacinto del Pindo

Maps
Scott Forbes

Authorizations
Instituto Nacional del Patrimonio Cultural
 del Ecuador
Museos del Banco Central del Ecuador
Instituto Geográfico Militar del Ecuador
Comuna San Jacinto del Pindo

FROM Myth
to Creation

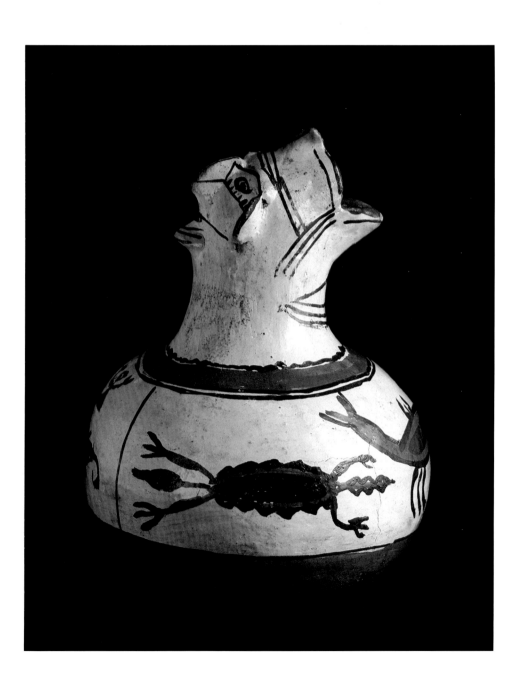

Effigy bowl representing myth
of Hilucu and Quilla.
Alicia Canelos, Sarayacu.

Zigzag design on three bowls.
Imitilia Hualinga, Canelos.

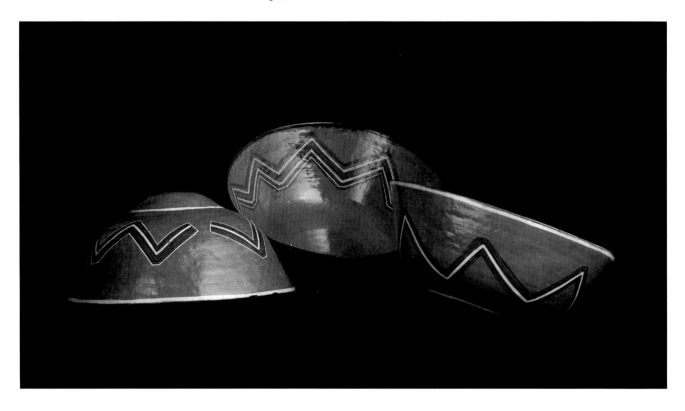

Anaconda, turtle, and iguanid
motifs on one bowl.
Alegría Canelos, Curaray.

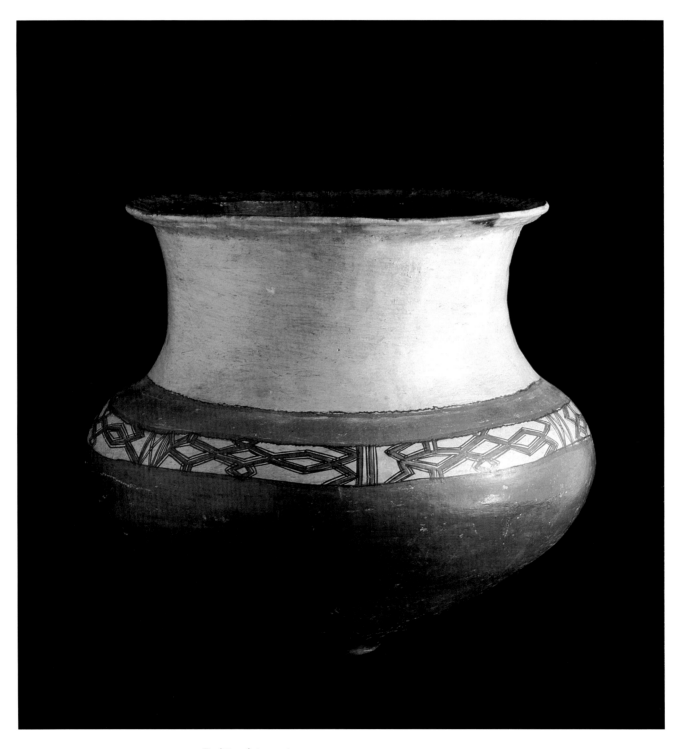

Traditional storage jar.
Faviola Vargas, Campo Alegre.

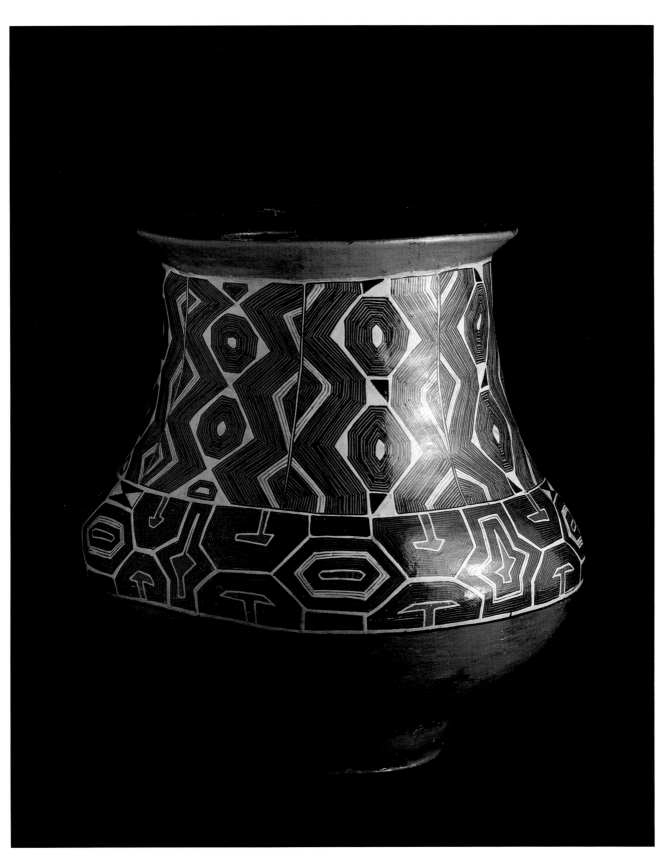

Storage jar made for ethnic-arts market.
Alegría Canelos, Curaray.

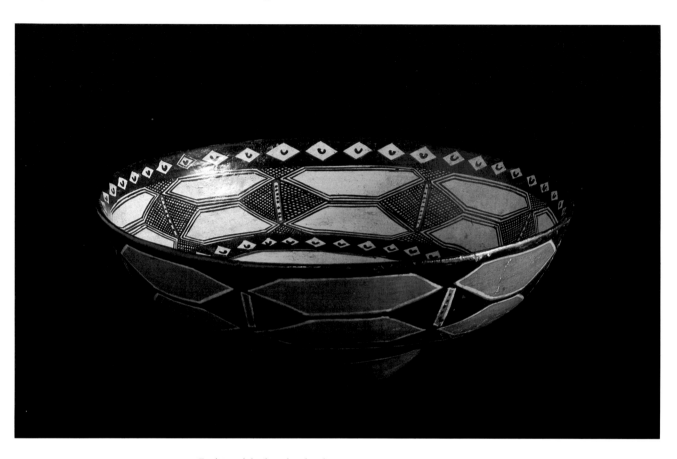

Traditional drinking bowl with
anaconda motif.
the late Pastora Watatuca,
Unión Base.

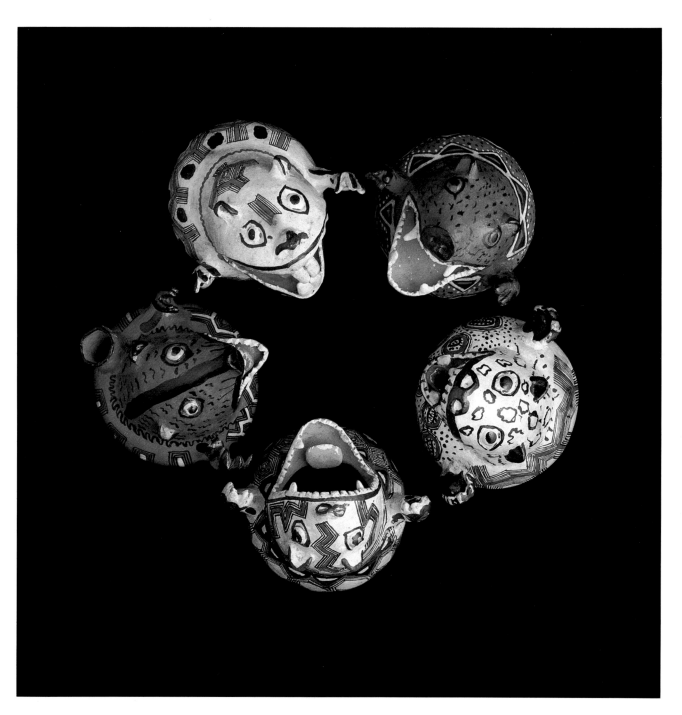

Effigy bowls representing animals of the rain forest.
Apacha Vargas, Nuevo Mundo.

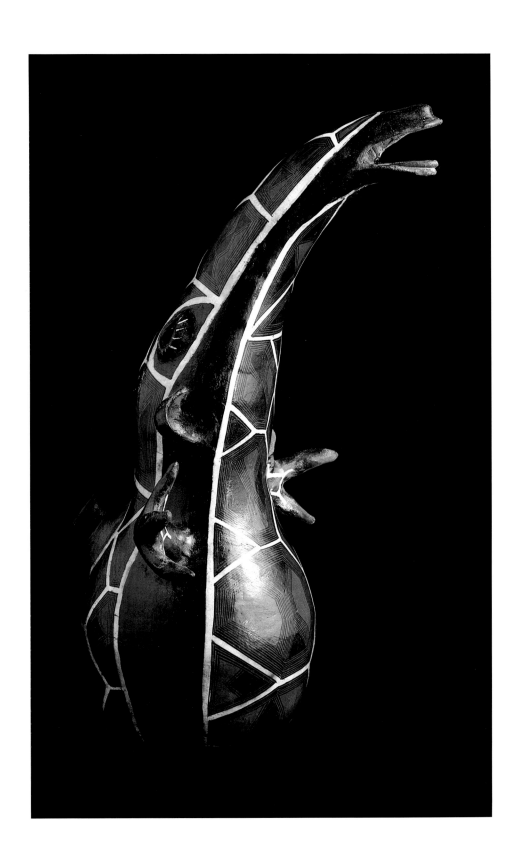

Effigy bowl in the form of a
giant anteater.
Esthela Dagua, Puyo.

Chapter 1

Introduction

Caru, caruman ringuichi, ñucaca nima uras cangunata cuti ricusha.

Rosaura Hualinga, of the Río Llushín, Pastaza Province, of Amazonian Ecuador, made the small pottery jar shown on the cover. It portrays the face of Nungwi, master spirit of pottery clay and garden soil. The shoulder of the pot is banded by the representation of the Amazonian water turtle, special seat of power of Sungui, spirit master of the water domain and first shaman.

Rosaura brought this and two similar jars to us in 1975, just as we were packing to leave Puyo. One was a gift, in return for medical care she had received; the other two were for sale. After we completed our negotiations, she squatted before her little jars and spoke very softly to them: "You are going far, far away, and I will never see you again."

Rosaura will see one of her jars again, on the cover of this book.

Canelos Quichua traditional and ethnic art and mythology are bound to and portray cultural antiquity. They are also part of the cognitive and symbolic ordering of rain-forest and riverine ecology and of contemporary life in a dynamic, radically changing OPEC nation. This book is intended to present Canelos Quichua art in its social and cultural milieux to readers interested in understanding art, aesthetics, and historical and contemporary consciousness of indigenous peoples of the Americas.

The Canelos Quichua of Upper Amazonian Ecuador are a relatively unknown people, in spite of a number of publications about their dynamic lifeways. Within Ecuador and internationally, Canelos Quichua pale against stereotypic images of "tropical forest Indians" and "real indigenous peoples." For example, native people from Santo Domingo de los Colorados (Tschachela), from Andean Otavalo and Salasaca, and people from other Amazonian areas (Waorani, Cofán, Siona-Secoya, Shuar, Achuar) are regularly showcased as specimens of national, indigenous heritage, while the Canelos Quichua are continuously misnamed (usually in pejorative terms) and often accorded neither national nor indigenous status. Their artistic products are frequently credited to other native peoples who do not share in the same rich, enduring traditions. Canelos Quichua symbolic portrayal of the structure and dynamics of rain-forest life through myth, legend, song, and graphic arts is as rich as that of the well-known Desana of Colombia or the Shipibo of Peru. Many aspects of mythology, and many of the creations that

stem from a deep knowledge of their rich ecosystem, have direct relationships to coastal, Andean, and Amazonian cultures.

Although the Quichua language does not have words for "art" and "artist," terms or phrases meaning "beauty" or "beautiful," "very knowledgeably made," and "strong, knowledgeable person" are used to describe admired objects and their creators. The exhibition this book accompanies, also titled *From Myth to Creation*, seeks to present the ceramics and other objects made by the Canelos Quichua from the perspectives of the creators. Appreciation of the people and what we regard as their art involves a sense of the inner Canelos world as well as the outer environing, hegemonic structure that today contains this small but important culture. This book is intended to convey an understanding of Canelos Quichua culture and people as a basis for more fully appreciating their art.

Canelos Quichua people actively participate in many facets of the contemporary world and are becoming increasingly bicultural in national and counternational lifestyles. They also vigorously maintain their language and cultural traditions. Prominent among their enduring traditions is the production of ceramics that are rich in indigenous symbolism. Over the past decade, as the Canelos Quichua have become drawn into a cash economy, they have developed wood carving into a thriving enterprise. But indigenous people who speak, look, and act in a national style yet make impressively beautiful and meaningful objects are paradoxical. They defy certain stereotypes of art and aesthetics held by many people in the nonindigenous world.

Nelson Graburn (1976:3) writes, "Though the terms 'primitive' and 'folk' art may have been satisfactory for the purposes of nineteenth-century Europeans, it now seems clear that such categories are hopelessly inadequate for any contemporary description." He adopts the phrase *arts of the Fourth World,* explaining that "the Fourth World is the collective name for all aboriginal or native peoples whose lands fall within the national boundaries and techno-bureaucratic administrations of the countries of the First, Second, and Third Worlds" (1976:1). Fourth-world arts, he argues,

> may be of two major types: (1) . . . the inwardly directed arts . . . made for, appreciated, and used by peoples within their own . . . society; these arts have important functions in maintaining ethnic identity and social structure, and in didactically instilling the important values in group members. (2) Those arts made for an external, dominant world; these have often been despised by connoisseurs as unimportant, and are sometimes called "tourist" or "airport" arts. They are, however, important in presenting to the outside world an ethnic image that must be maintained and projected as a part of the all-important boundary-defining system. (1976:5)

Festival pot in the form of a monkey-person, Machin runa. Such a depiction evokes imagery of external domination and of internal liberation. Esthela Dagua

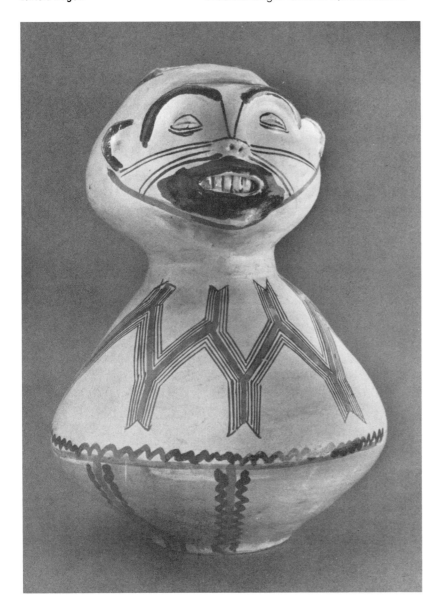

Canelos Quichua ceramics are inwardly directed arts, inspired by the essence of a culture bound up in an ancient cosmology communicated through rich mythology. In addition to ceramics made for everyday household and periodic ceremonial use, a few potters create pieces expressly to enlighten outside audiences through exhibitions. A number of women are augmenting their family income by producing ceramics to sell in the ethnic-arts market. These ceramics, which are also traditional, are among the finest still being made in Amazonian South America. Nonetheless, when they reach the ethnic-arts market they are often attributed to neighboring Jivaroans, who are noted for more exotic ("primitive") customs and garb.

By contrast with the traditional ceramics, the Canelos Quichua wood-carving industry developed as a direct response to economic pressures. It was not introduced by entrepreneurs; rather, it grew out of the men's knowledge of the rain forest, its products, and its wildlife. It could not have begun without men's skill in making traditional, functional items; nor could it have flourished in the ethnic-arts market without technical knowledge and advice from a North American artist. From its inception, wood carving was outwardly directed, and it rapidly became tremendously popular in the Latin American ethnic-arts market. Again paradoxically, these Canelos Quichua carvings, which reflect the vibrancy of the rain forest, are frequently credited to craftsmen from Andean or coastal areas of Ecuador, including urban Cuenca and Quito, from Central America, and even from Mexico.

In his article "'I like things to look more different that that stuff did': An Experiment in Cross-Cultural Art Appreciation," Graburn (1978) convincingly demonstrates the importance of contextual phenomena in making aesthetic judgments. He writes: "There is massive evidence that the aesthetic judgments were made in terms of the expectations the audience had about the kind of people the creators were and the life style being communicated" (1978:68). Graburn cites a number of evaluations of native art that correspond to our own observations of the marketing of Ecuadorian ethnic and traditional art, as well as to our own experiences in producing museum and gallery exhibitions.

Stereotypic political-aesthetic judgments are obviously at work when Canelos Quichua ceramics and wood carvings are mislabeled in the marketplace. In galleries in the United States we have heard Canelos Quichua ceramics likened to Mexican papier-mâché products, and thereby relegated to mass production of curiosities devoid of meaning and without internal evocative power. And we have witnessed the outright rejection of exquisite bowls because "They are too fine to be made by traditional techniques!" Creators of strikingly naturalistic carvings of macaws or toucans have been criticized for catering to Western tastes in art by making the birds realistic; when it is pointed out that the realism stems from a genuine knowledge of bird anatomy and behavior, a common retort is, "But they made them for money." According to such stereotypic evaluations, "commercial art" and "native art" are mutually exclusive concepts.

One set of our experiences with exhibitions of Canelos Quichua art is well summed up by a museology student's suggestion of how to display a very ordinary looking drum: "Well," he said, after studying the piece for a few minutes, "maybe on purple velvet." His intent was serious; he wanted a dramatic setting for what he took to be a humdrum item. He was unaware that the drum was, in fact, quite significant in the shamanic, ritual, and everyday life of the people. On another occasion, a talented potter in the United States was fascinated by Canelos Quichua ceramics and by the fact that the people were developing a small museum in indigenous territory. She sent them a handsome vase she had made, to be placed in their museum as a token of respect and admiration. Her gift was appreciated but puzzling to those in charge of the museum, which had been established by a group of Canelos Quichua to maintain their own traditional knowledge expressed through their own material culture.

The presentation of indigenous art by museums is subject to widely differing interpretations, two of which fall so far outside our perspective that they should be mentioned here. Kristin Helmore, for example, in a *Christian Science Monitor* (1984) article about native North American art exhibitions, writes:

> Why does so-called "primitive" art appeal so strongly to our modern taste? Perhaps because it is direct, unpretentious, and has such a strong sense of integrity of purpose. Almost invariably, . . . primitive art is linked to worship. It also happens to obey many of the rules of form, order, and balance that

Carlos Machoa, director of the music group "The Crazy Toucans," wearing a toucan headdress and playing a violin adorned with a parrot head. The toucan is a symbol of liberation in Canelos Quichua culture.

ingly, we adopt an *ethnoaesthetic* perspective that insists on presentations of art, and generalizations based on these presentations, from the standpoint of the creators themselves. As this perspective has been developed by the work of Sally Price and Richard Price (e.g., 1980), an ethnoaesthetic presentation is designed to promote the understanding of unique aesthetic traditions and art forms in their social and cultural milieux, as well as to communicate this understanding across cultural boundaries. *Communication* is the key. Genuine ethnoaesthetics in the modern gallery involves close attention to inner meaning generated from within the culture of the creators and to a presentation that can be readily grasped by the gallery visitor.

In 1976 we offered a modest exhibition at the Illini Union Art Gallery, in Urbana, Illinois. During the month that the exhibition was shown, we received many queries and comments from academicians, students, townspeople, and schoolchildren that indicated an intellectual and even an emotional yearning for knowledge of the cultural significance of traditional- and ethnic-art objects. People genuinely wanted to appreciate what they were seeing, and their questions raised ideas that had to be expressed along with material displays. This signaled the need to group and interpret objects thematically, to direct viewers' attention to fundamentals of Canelos Quichua life that are understandable in general terms. Throughout ensuing exhibitions in the United States and in Ecuador, we have worked with four themes: Sustaining Life, Control of Power, Self-Presentation, and the Sounds of Spirits. These themes, including the contrasts, reflections, and interplays among them, have constituted the core of a series of ethnoaesthetic presentations. We have incorporated more and more spiritual, mythical, and ecological interpretations and graphic representations as these have been revealed to us through years of continuing fieldwork and research.

The merits of ethnoaesthetic presentation were highlighted during two exhibitions designed and shown in Ecuador in 1987. The first was held in the national art gallery of the Central Bank of Ecuador, in Quito, to celebrate the European discovery of the Amazon in 1542 by Francisco de Orellana. The second was held in the public library of the Municipal Building in Puyo, capital of

we have set as our criteria for judging aesthetics — although it does so in refreshingly unorthodox ways. In addition, it has an exotic, mysterious quality for us, offering a glimpse inside a world, a mentality very different from our own.

While Helmore finds a universal primitivism in native art, another perspective, that meaning in art is revealed by the trappings of modern museology, is expressed by Hilton Kramer (1982:62):

> . . . in the tightly controlled design environment of the museum, where stagecraft inevitably triumphs over expression, the savage gods of primitive art are expelled, and in their places are offered a succession of benign and wondrous forms. Can we still then claim to have had an experience of primitive art? . . . what the museum brings us face to face with is a mirror in which we see the magic of our own technology and taste.

We disagree with the extreme views that "primitive art objects," in and of themselves, emanate exotic, mysterious qualities, or that the modern museum must salvage "primitive art" and project it into a "modern" aesthetic mold to be appreciated. Accord-

Pastaza Province, to mark the legendary founding of the town in the name of church and state in 1899. The crowded opening of the first exhibition included many Ecuadorians prominent in art, commerce, and government, a handful of North Americans, a sprinkling of native Otavalans, and one indigenous Canelos Quichua couple who had come from Puyo to attend this important event. The indigenous man was consulted constantly during the evening by legislators and others about the quality and nature of native life and about the representations of such life through the materials and photographs displayed in the exhibition. He took pleasure in his role as cultural interpreter and broker and effectively used the ethnoaesthetic presentation to deflect nationalist stereotypes and to assert indigenous reality.

Two weeks later we returned to this exhibition with thirty-one Canelos Quichua artists who had contributed to it. Although many could not read the texts, they recounted the cultural meanings of everything they saw, frequently anticipating what they would see next, and explained all of this to an Otavalan Quichua-speaking museum guide. She, in turn, later led them through the permanent archaeological exhibition of the same museum, where an hour-long spirited exchange of information took place in two Quichua dialects that are widely believed to be nearly unintelligible to one another.

Subsequently, a number of Canelos Quichua men and women helped to plan and produce the exhibition in Puyo. Hundreds of native peoples, and hundreds of non-native peoples, visited this display, some repeatedly. Again, reflective comments and discussions by the Canelos Quichua revealed their total familiarity with the contextual presentation of the objects. Although most of them had never seen a museum exhibition, much less thought about "design," they acted as though they had conceptualized the actual presentation — and in many ways they had. They commented specifically on aesthetic reference points that led from one set of ideas to another, recounting the basic points in their own language. Those very reference points guide the presentations in the exhibition for which this book was prepared, as we endeavored to capture the framework of Canelos Quichua thought, expression, beauty, and knowledge.

The essence of Canelos Quichua culture may be seen in an ancient cosmology and a rich mythology that relate beliefs about the universe to contemporary life by reference to ancient and immediate ancestors. The substance of Canelos Quichua life is bound to the dynamics of radical change within a developing OPEC nation-state. The exhibition *From Myth to Creation* presents tangible examples of art inspired by Canelos Quichua culture in both its traditional and modern dimensions. The book *From Myth to Creation* complements the exhibition, to give lasting recognition to Canelos Quichua artistry drawn from deep cultural knowledge, mythology, legend, history, and daily events, and to communicate inner meanings across international, interethnic, and intercultural boundaries.

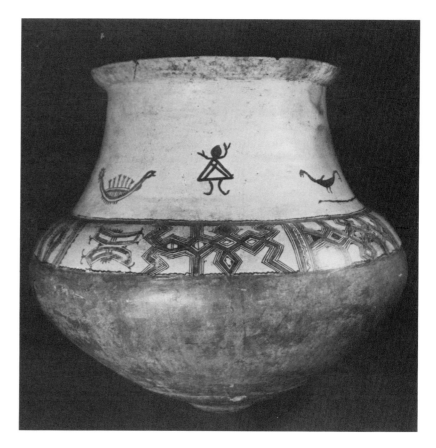

Traditional storage jar for fermented manioc mash. The decorative band around this huge *tinaja* portrays *amarun*, the giant multicolored anaconda, the ultimate source of power.
Alicia Canelos

Chapter 2

The Canelos Quichua People

The Canelos Quichua speak one of many northern (Ecuadorian) dialects of Quechua, language of the Imperial Inca. Their language, Quichua (pronounced *keéchua*), is frequently, though erroneously, associated exclusively with the high Andean regions of Ecuador, Peru, and Bolivia. Today many variants of Quechua are spoken by twelve million or more people ranging from Colombia to Argentina, including Amazonian and other lowland regions of these nations, as well as the associated highland areas. Quichua was a language of conquest in Andean Ecuador. In the fifteenth and sixteenth centuries A.D., Quechua spread northward and southward from the city of Cuzco, in what is now Peru, as a lingua franca of the Imperial Inca. It continued to spread in what today is Ecuador in several ways: by Incaic conquest of the Andean zones for a brief period of time; then as the official language of Spanish colonial rule of native peoples; and in other manners such as intra-indigenous trade and indigenous resistance to colonial hegemony. While it is clear that the language was spread throughout the Central Andes and part of the Northern Andes by Incaic invasion, its early penetration into what would become Canelos Quichua territory and its domination over Jivaroan and Zaparoan languages in parts of Ecuador's Amazonian region remain intriguing problems.

The heartland of Canelos Quichua culture is in the middle region of the Bobonaza River, Pastaza Province, but the culture area extends from the foothills of the Andes to the low-lying, true Amazonian rain forest in the areas of Montalvo and Curaray. The largest concentration of people, perhaps half of the entire population of 10,000, reside at the base of the Andes, in a verdure, canopied, montane arc surrounding urban Puyo. Runa (pronounced *róona*) is the term for human beings used by the Canelos Quichua. People also identify themselves by place-names; for example, Curaray Runa come from the Curaray River region, Puyo Runa from the greater Puyo area, Canelos Runa from Canelos. Many, especially the men, are bilingual in Spanish, and more than 20 percent share cradle bilingualism in Achuar Jivaroan. Although Zaparoan was once thought to be nearly extinct in the region, there are now several areas of clear Quichua-Zaparoan bilingualism.

The Canelos Quichua are representative of today's dynamic Amazonian peoples. They emerged in their territory — that radiating out of such riverine sites as Puyo, Canelos, Pacayacu, Sarayacu, Teresa Mama, and Montalvo, spreading north from the Bobonaza River to the Curaray and Villano rivers — as a formative culture, just as the Catholic missions, first Jesuit and then Dominican, strove to establish European hegemony in their territory. For the past century, as before, Canelos Quichua have repeatedly experienced waves of foreign intrusion and exploitation. Within recent memory are the late-nineteenth-century Amazon rubber boom, the discovery of petroleum, World War II, and the rediscovery of petroleum in the early 1970s. The Canelos Quichua and their contemporary neighbors — Napo Quichua and Waorani to the north, Shuar and Achuar to the south and east — continue to represent two facets of Ecuadorian life that are characteristic of a significant segment of the republic: quintessential identity as a bona fide nation of indigenous peoples, and a people secure in their new nationalist identity as Ecuadorians.

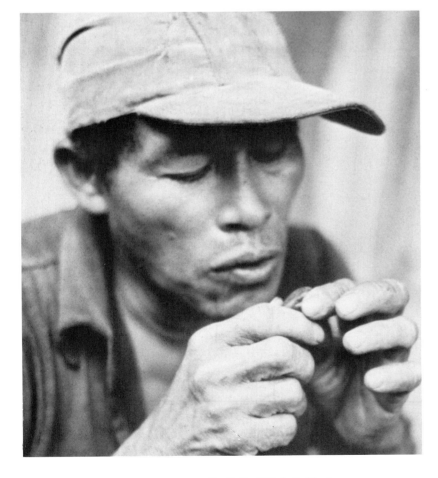

Camilo Santi Simbaña blowing
on a spirit stone

Although many of the Canelos Quichua come and go from towns and cities, including Quito, the capital of the Republic of Ecuador, they are as competent in traditional rain-forest and riverine life as their more "exotic" Shuar and Achuar Jivaroan neighbors, with whom they intermarry. Traditional economic activities in which they constantly engage include hunting, fishing, and swidden horticulture focused on manioc and other earth vegetables (often called root crops), and on plantain and palm cultivation. Their modern economic activities include sporadic wage labor, domestic service, cattle raising, and commercial forest exploitation of the soft and hard woods of the region. Politically, they exercised their collective voting power in 1984 to radically alter the power structure of Pastaza Province. Their participation in current Ecuadorian politics varies: some are apathetic, while others take vigorous stances along a polarized political spectrum, including outright resistance to sectors of modern politics that may be seen as hegemonic.

The indigenous social organization of the Canelos Quichua is centered on a very complex system of kinship and marriage (see Whitten and Whitten 1984). Marriage may result from romantic love and elopement, but preferably it occurs through highly structured exchanges of sons and daughters arranged by parents and even grandparents. Inherited and acquired soul substances, representing the essence of continuity through generations, are transmitted by mothers directly to their daughters and by fathers to their sons through the mothers. There are two different systems of residence, nucleated hamlet and dispersed residential territory. All people utilize both systems. The hamlet represents minimal features of political-economic control of the nation-state; the dispersed residential system reflects the cultural ecology of Amazonia. Actual residence combines factors of kinship and marriage, both of which are governed in part by the activities of powerful shamans.

The apex of each segment of the social system of the Canelos Quichua is the shaman. He achieves his position through his knowledge of and experience in traditional and contemporary worlds. Each powerful shaman has a sister and/or a wife who is a master potter, and these knowledgeable men and women transmit the symbolism of tradition and modernity to their offspring. Men and women reared in this complex of culturally transmitted knowledge and experience are as familiar with their counterparts' gender role as with their own, and each may serve as an interpreter for the other. A powerful image-making woman "clarifies" a shaman's

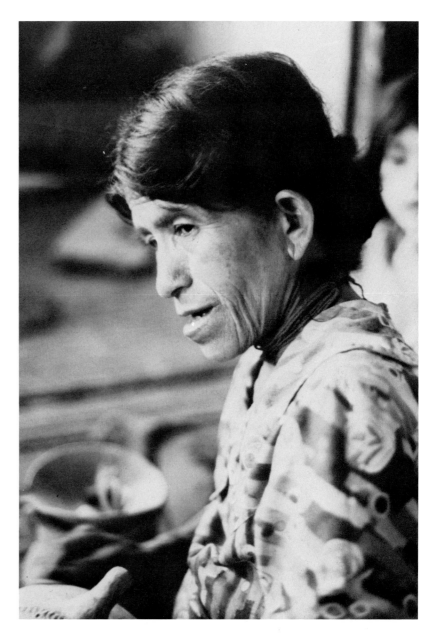

The late Soledad Vargas,
master potter

visions while he is in seance, and a shaman himself, while chanting, may bring to consciousness symbolism deeply embedded in his wife's or his sister's ceramic art. What binds these distinct yet merged male/female domains is an ancient, enduring cosmology.

Culture History

When we consider the culture history of the Canelos Quichua we must note that the mainland portion of the Republic of Ecuador is sharply divided into three regions: coastal, Andean, and Amazonian. In Ecuador, more than in any other country of South America, these strikingly different topographical regions are very close to one another, permit-

ting reasonably fluid contact and trade (as discussed by Salomon 1981:192-95). Indeed, there is archaeological documentation of trade networks among these regions 4,500 years ago and of coterminous pottery traditions 3,500 years ago, at a time when trade networks were expanding (Marcos 1986). It is also very important to note that the archaeology of Ecuador reveals that agricultural development and ceramic manufacture occurred 1,000 years earlier than in Peru or Mexico (Collier 1975:8; Marcos 1986).

Literature on the archaeology of Amazonian Ecuador is scant but provocative. It is clear that agriculturally based towns with large burial mounds and a central plaza existed in the region just south of what is now

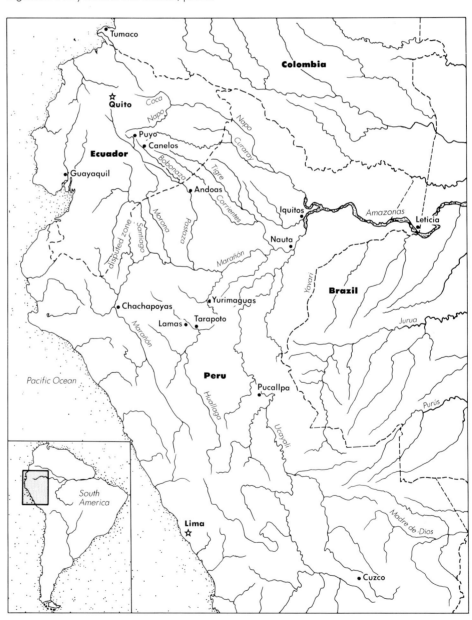

Western South America

Canelos Quichua territory between 1,500 (or earlier) and about 500 years ago (see, e.g., Porras 1987). Ceramics from this area are unrelated to Jivaroan pottery characteristic of the region from the time of the Spanish conquest to the present. Stylistically, the ware looks as though it could have been a distant antecedent of the Canelos Quichua pottery of the past few centuries. In 1987, the Achuar Jivaroans of the area of Charapa Cocha made public note of what they took to be an ancient city of souls governed by spirit master Sungui. The pottery urns that they presented to officials of the municipal government of Puyo, capital of Pastaza Province, look strikingly like a phase of ceramics that could have developed somewhat later than Napo pottery to the north and Sangay pottery to the South. The Achuar insist that this ware is not of their own ancestors. The Canelos Quichua who have seen it claim that their ancestors made it. Pedro Porras Garcés (personal communication, 1987), the eminent authority on this area, estimates a date between 1,500 and 500 years ago for this ware. This exhibition is fortunate in having two pieces from the Charapa Cocha area for display.

Sites of material remains of ancient cultures of a half millennium ago must be understood through time in terms of Euro-American colonial history, ethnohistory, and archaeology. Raiding and plundering native villages during his trip eastward from Quito to discover the sources of the mighty Amazon River in 1542, Francisco de Orellana, as recorded by Friar Gaspar de Carvajal, noted with care many qualities of the very fine ceramic ware produced by peoples of the Upper and Middle Amazonian regions.

> In this village there was a villa in which there was a great deal of porcelain ware of various makes, both jars and pitchers, very large, with a capacity of more than twenty-five *arrobas* [100 gallons, transl.], and other small pieces such as plates and bowls and candelabra of this porcelain of the best that has ever been seen in the world, for that of Málaga is not its equal, because it [i.e. this porcelain which we found] is all glazed and embellished with all colors, and so bright [are these colors] that they astonish, and, more than this, the drawings and paintings which they make on them are so accurately worked out that [one wonders how] with [only]

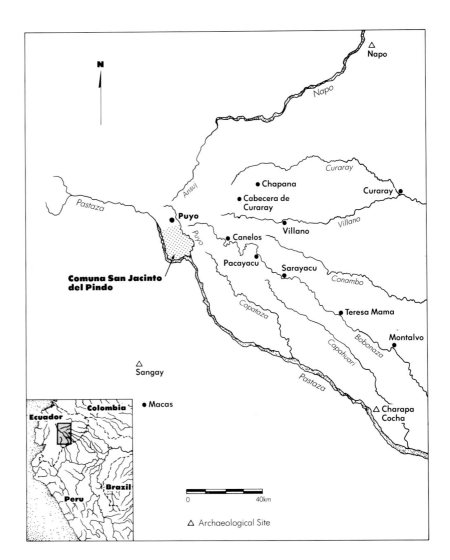

Canelos Quichua Territory
of Ecuador

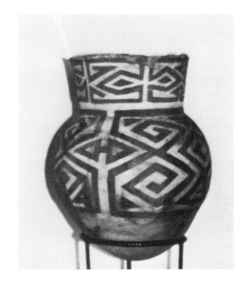

Charapa Cocha urn

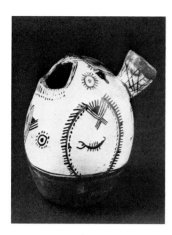

Jista Puruwá: form of an owl, symbolic of shamanic attack
the late Eusebia Aranda

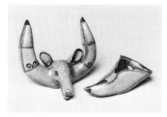

Drinking vessel in the form of a cow horn, and a cow head effigy
Martha Vargas

natural skill they manufacture and decorate all these things [making them look just] like Roman [artifacts]; and here the Indians told us that as much as there was made out of clay in this house, so much there was back in the country in gold and silver, and [they said] that they would take us there, for it was near; and in this house there were idols woven out of feathers of divers sorts, which frightened one . . . This race of people resides in the interior of the country and is the one which possesses the riches already mentioned, and it is as reminders that they have them [i.e. the two idols] there: and in this village also there were gold and silver. . . . (Carvajal 1934 [circa 1542]: 201; emendations are translator's and editor's)

Many of these people, especially those speaking dialects of Tupian, were in the process of western migration at the very time they were being "contacted" by eastern-moving Iberians. Tupians were searching for the "land without evil"; they were led by powerful shamans who were prophets as to the location of the sacred land and leaders in the vast treks to find it (Métraux 1927; Shapiro 1987). One ten-year-long Tupian trip in 1549 clearly moved into Chachapoyas, Peru, an area claimed by some Canelos Quichua as part of their western-most homeland (Métraux 1927:21; Shapiro 1987:131; Whitten 1976:30, 1985).

As these western movements of Amazonian peoples were underway, it is probable that dialects of "Lowland" (Amazonian) Ecuadorian Quichua were spreading from the south and southeast into the regions drained by the lower Pastaza River, the Huasaga River, and eventually the Bobonaza River, entering what is now Pastaza Province earlier than, or at about the time of, the Incaic conquest of what today is Andean and coastal Ecuador. The Quichua language dialect that was to become Canelos Quichua became a lingua franca by which Achuar Jivaroans and various Zaparoan peoples became united. Out of the conjunction of dynamic cultural currents characterizing Amazonian Ecuador during the first century of colonial hegemony, the Canelos Quichua people, who today are often identified as Pastaza Runa, emerged as a distinct, surgent, formative culture with clear-cut ethnic markers. These include their language (a dialect more closely linked to the Quechua of Cuzco and Ayacucho, Peru, than with other Andean Ecuadorian Quichua dialects); a male tradition of powerful shamanic activity strikingly similar to that of native peoples ranging from southern South America to the Arctic and around the rim of the Pacific into South Asia; and the manufacture by women of both polychrome and blackware ceramics with roots in deeper Amazonia.

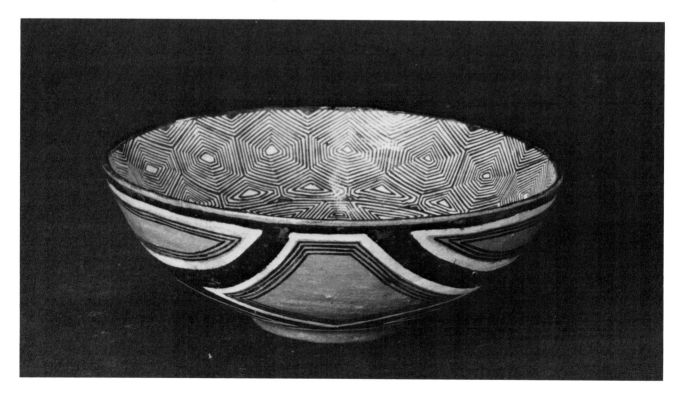

Mucawa
Delicia Dagua

The Ceramic Tradition

Today, some 445 years after Carvajal and Orellana commented comparatively on the strength and beauty of the Amazonian ceramics they "discovered," Canelos Quichua women continue to demonstrate their remarkable adaptability to modern life, on the one hand, and a strikingly apt reference to their enduring traditions, on the other. The integration of tradition and modernity, of continuity and change, are graphically represented by the production of thin-walled, hand-coiled ceramics.

Production of *aswa* is basic to the painted ceramic complex. *Aswa* is a mildly fermented manioc food beverage that is fundamental to the Canelos Quichua diet. It is made by boiling cleaned and peeled roots of an earth vegetable commonly known as manioc, or cassava (*Manihot Esculenta*). Cooked roots are pounded into a pulp in a large, flat wooden bowl. Some of the pulp is then gently masticated to provide the proper yeasts for fermentation which is necessary for storage in the moist tropics. An enzyme in the saliva, ptyalin, converts starch into dextrine and maltose. Yeasts that cause fermentation also supplement the scant vegetable protein of the starchy, energy-rich root.

Both spheres of activity — making ceramics and making *aswa* — are the exclusive domain of women. Women cultivate and carefully prepare manioc from which they make *aswa*. They make an array of polychrome vessels, including large jars in which manioc pulp ferments and is stored, bowls for serving *aswa* every day to household members and guests, and special bowls and figurines to serve *aswa* during periodic ceremonies and festivals. In addition, they make blackware pots to cook manioc, other foods, spices, and drinks, and blackware bowls to serve cooked food.

Techniques of ceramic production and the forms of many vessels are derived from ancient Upper Amazonian traditions. This is especially apparent in the variety of blackened cooking and eating ware that has been compared to the entire spectrum of Tupi-Guaraní pottery that spread throughout the vast area of what is now Brazil and Paraguay (José Brochado, personal conversation, 1979). The basic symbolism in the painted decorations also reflects ancient cosmological premises and knowledge systems. Today, many Canelos Quichua women continue to make their ceramics, just as they maintain other traditional knowledge systems, in the face of a radically changing environment and increasing political-economic pressures emanating from the national consolidation of Ecuador's frontier zones.

A fundamental distinction made by the Canelos Quichua themselves is between blackware and polychrome ware, both of which are hand-coiled. Blackware is made for cooking food and beverages and for serving cooked food and beverages. A heavy grade of clay with a natural mix of quartz crystals, sand, and tiny pebbles is needed for cooking pots to withstand repeated, direct exposure to hot fires. Runa seek out special sites that they mine with machetes and shovels, returning home with hundreds of pounds of clay that requires no additional temper. After the pot is fired at a temperature of at least 1,500° Fahrenheit in what resembles a crate made of bamboo, it is allowed to cool. Then the interior of the pot, and occasionally some of the smooth exterior, is rubbed with taro or sweet-potato leaves, the sap of which provides an oxygen-reducing substance. The pot is then refired at least once more in an oxygen-reduced atmosphere, and the resulting shiny brown-to-black color is created according to the design of the potter.

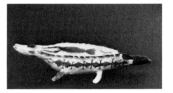

Iguanid figurine
Amadora Aranda

Tinaja with painted iguanid
(*ayambi*)
Amadora Aranda

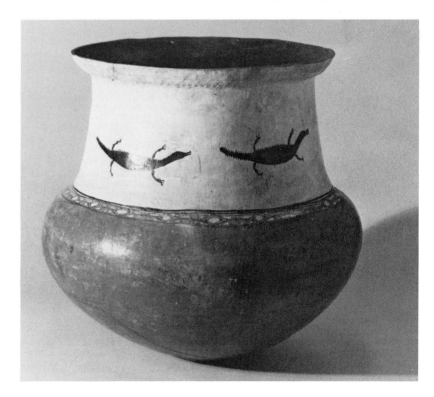

Polychrome decorated ware is made exclusively for storing and serving *aswa*. Men and women trek to different mines, seeking clay deposits with small, naturally distributed quartz crystals. The smoothest paste is used for drinking bowls, a courser clay for the large storage jars. Black, white, red, and yellow clays and rocks used for slipping and painting come from nearby and far away, and an active trade is maintained by master potters to assure an abundance of the proper dyes and slips. There are two techniques for firing the polychrome bowls. The large jars and the figurines are fired in a crate, like the blackware, the temperature varying from 1,300° to 1,700° Fahrenheit. As the piece cools slightly it is coated with a lacquer from a tree resin called *shinquillu* (possibly Brazilian Elemi, *Protium Heptophyllum*). Drinking bowls are inverted, one at a time, in a round clay frame and fired over brightly burning logs for about thirty-five to forty minutes at 1,500° Fahrenheit; they are also lacquered with the same carefully prepared tree resin. Analysis of this pottery by scientists in the Program on Ancient Technologies and Archaeological Materials (ATAM) of the University of Illinois indicates that the Canelos fire for optimum times at optimum temperatures for the naturally tempered clay to produce an exceptionally strong and delicate piece of ceramic art.

Ayawasca manga
(for brewing *Banisteriopsis caapi*, a hallucinogen)
Esthela Dagua

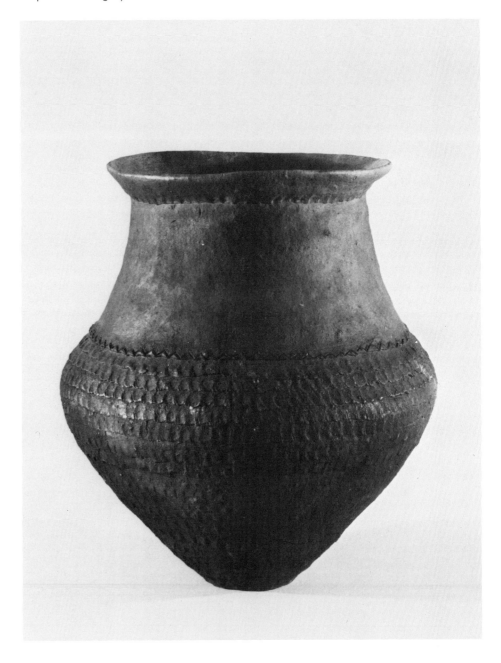

The most prominent form of the polychrome ware is called *tinaja* (Spanish) or *aswa churana manga* (*aswa* decorated jar, Quichua). A handful of fermented manioc pulp is taken from the large jar and placed in a drinking bowl, called *mucawa*. There it is mixed with preboiled water and served by women of the household to women, men, and children. Other small jars, called *sicuanga manga*, toucan pots, are used to store feathers, beads, or other secret substances. They are hung high in the rafters of the house, often out of sight. Some figurines replicate in three dimensions the designs and motifs painted onto the jars and bowls. All designs represent life forces, living beings, and spirit sentiences of rain-forest, garden, and water worlds, animated to a social existence through rich and elaborate mythology.

A girl may learn to make pottery at her mother's knee, or she may learn later from her mother-in-law or another close female relative. Actual production of pottery varies according to immediate circumstances, which change as a woman moves through her life cycle. Creative ability is different for each woman; the highest level of skill is achieved by those whose mastery of knowledge allows them to control the symbolism of their universe. Basic designs known by all women are natural representations associated with the rain forest and the river. These are also profound cultural expressions of cosmic force, which include anaconda, iguanid, tortoise, and turtle.

A simple zigzag represents anything that is bent or twisted, such as a river. A partially filled zigzag symbolizes hills. Anaconda imagery is signaled by a series of triangles and by spots. Tortoise and turtle images are depicted realistically by the geometric patterns of their shells. An elongated, hexagonal design denotes iguanid imagery.

Three spirit masters are dominant symbols for the Canelos Quichua and in one or another transformation come to be represented in ceramic art. These include Sungui, spirit master of the water domain; Amasanga, spirit master of the rain forest; and Nungwi, spirit master of garden soil and pottery clay. More will be said later about these pivotal spirit beings and forces.

The peak of creative activity occurs when a woman prepares an array of pottery

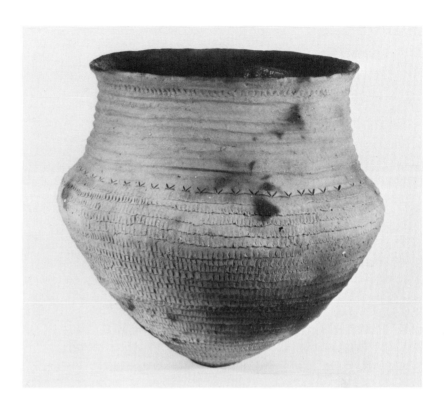

Yanuna manga
(for cooking manioc)
Esthela Dagua

Callana
(for serving cooked food)
Alicia Canelos

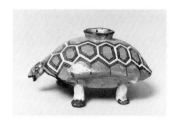

Charapa
(Amazonian river turtle)
Apacha Vargas

Ayambi (iguanid)
Apacha Vargas

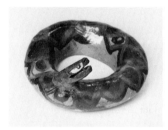

Amarun
Elsa Vargas Santi

for a festival. She draws on her deep cultural heritage, her ecological knowledge, and her personal observations to recreate ancient images for this present event, a time and place where human and spirit worlds are conjoined. The festival is a time of conceptual expansion, when *everything*—animals, plants, spirits, and souls — is regarded as existing in the contemporary, living indigenous world. Many of the forces that are revitalized during these events are represented by special effigy jars made with serving spouts. During such festivals external, nonindigenous threats and intrusions are invited and challenged, and the indigenous cosmology is reaffirmed to assure continuing survival for other periods of time.

An especially strong drink is made for festivals. First an orange-colored neurospora fungus is sought where fire has recently burned in a swidden garden. Then large amounts of entire manioc roots are roasted on a bonfire built in the *chagra*, the neurospora fungus is added, and leaves are placed over the pile of roots. In a few days orange and white fungi cover the roots which are then briefly masticated, pounded, and placed over a screen in a *tinaja*. In about a week the entire bottom of the storage pot is filled with a liquid much like hard cider. This is the *vinillu* (from the Spanish word for "wine"). First the *allu aswa* (mold *aswa*) is removed, then the screen, and then the *vinillu* is carefully dipped out and put in separate storage jars. The *vinillu* is carried around the festival house in a huge, beautifully decorated bowl, called *chayuj marcana mucawa* (bowl held by the convenor of the festival), and women and men use special small bowls to dip from it and to serve guests. The effect of the *vinillu*, as with its appearance, is much like hard cider, perhaps because of a common cyanotropic effect.

Pottery figurines, *jista puruwá*, are made for these festivals to serve *aswa* and *vinillu*. Many of these pieces represent ancient mythical and spiritual beings that remind everyone of their shared ancestral roots, which stem from Mythic Time-Space and from Beginning Times-Places, and continue through antiquity to Times of Destruction and on down to Times of the Grandparents. Other effigies are of wildlife, and some are of the spirit world. These ceramic expressions of mythical beings and existing wildlife take their place beside statements about everyday human experience. For example, thinking of the imagery that bees bring to the shaman after he has taken his soul-vine brew, a woman might create a beehive. For her this is a honey bee festival pot (*mishqui puru*),

representative of a valued natural forest product. But she also knows that it can symbolize, for men, a spirit bee-helper (*supai bunga wasi*).

Women don special necklaces and paint their faces with black *widuj* from the *Genipa americana* tree to symbolize the mythic union of Quilla, the male, roguish moon, with his sister and lover, Hilucu. So adorned, women serve gallons upon gallons of *aswa* and smaller portions of the much stronger *vinillu* to the festival participants from ceramic figurine vessels they have specifically created to represent these important mythical figures.

Men, similarly painted and decorated with feathers, bones, and skins of birds and animals symbolic of the forest spirit Amasanga, raise their drumming and flute playing to a crescendo, complementing women's songs about mythical beings, early ancestors, historical heroes, recently deceased family members, special trips to faraway places, and feats of traditional and modern accomplishment. Through music, humans are most closely conjoined with the spirit world, for musical performance, and even silent thoughts about melody and rhythm, are believed to evoke and transmit complex concepts from *unai* (Mythic Time-Space) and from *callarirucuguna* (Beginning Times-Places). Music itself, it is thought, comes from the spirit world and passes through creative humans to transmit complex thoughts and feelings to other humans, and from humans to spirits.

During festive ceremonies, the intrusiveness of the outside world is always incorporated into the indigenous knowledge system. This is most apparent in the ceramic images potters create to comment on contemporary life. Often, for example, a woman will make an effigy pot in the form of a monkey and say that this represents the new foreigners who are less than human but may come to dominate the contemporary Runa. In ancient times and places, it is said, monkeys themselves had festivals high in the trees, where they drank various beverages from natural containers such as nuts and pods. (The naturalist Alfred Russel Wallace [1853], by the way, noted the use of "monkey calabashes" in his Amazonian travels during the mid-nineteenth century.) To signal this some women represent natural containers by

Jista Puruwá with stylized
zigzag *(quingu)* motif
around shoulder and neck

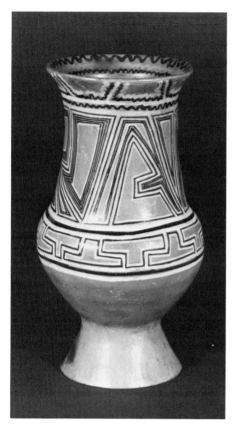

Sicuanga manga with
tortoise motif

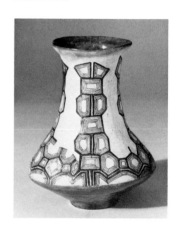

Tinaja with turtle *(charapa)*
motif
Apacha Vargas

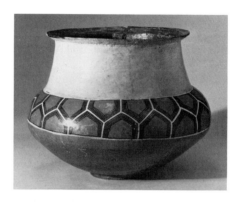

Mucawa with horizontal zigzag
motif and vertical anaconda
motif (inside, above and below
zigzag), and iguanid motif to
right. Zigzag and vertical
anaconda are on the outside.

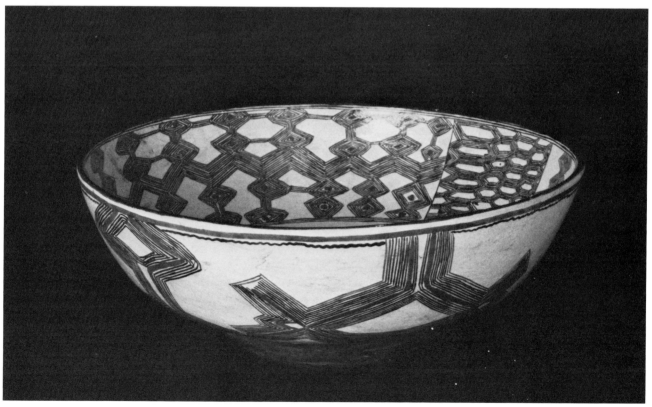

Ticks, before and after
engorging with cattle blood
Apacha Vargas

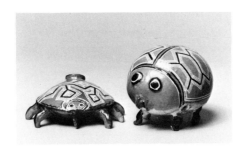

Array of ceramic drinking
vessels made as natural
gourds or calabashes
Juana Catalina Chango,
the late Pastora Watatuca,
Amadora Aranda

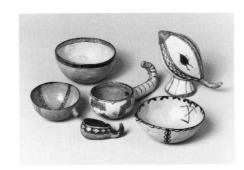

Bee
Apacha Vargas
Beehive (*mishqui puru*)
Esthela Dagua

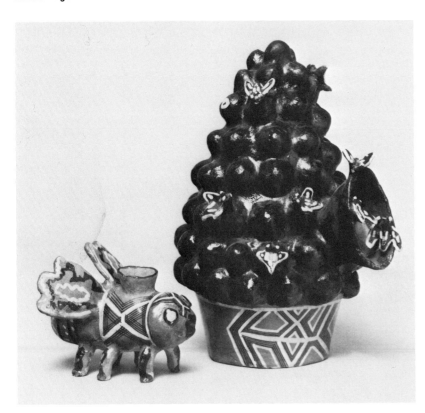

making serving vessels in the form of pods or nuts, thereby integrating mythical nature with contemporary depictions of foreign intrusion. Others make effigy bowls of monkeys themselves and are sure to include a natural pod in the monkey's hand.

All women in Canelos Quichua culture are expected to know how to make pottery, but only a few achieve the level of artistry that we would call "master potter." Whether neophyte or expert, many Canelos Quichua women balance traditional knowledge with modern experience through their adaptability and keen sense of humor. Graphic expression of these qualities is seen in the production of serving vessels that mock some aspects of the changing world – a jukebox, a petroleum engineer riding in a canoe, Godzilla, a cow horn, cow ticks, and a soup spoon.

Basic to the complex cosmology, which permeates every aspect of a festival or ceremony as well as shamanic activity and ceramic creation, is an interrelated set of beliefs regarding the integration of knowledge, reflection, and self-regulation to control power and to counter the devastating effects of unleashed power. Such knowledge, in turn, is drawn from mythology, legend, history, and direct experience to constantly construct an enduring sense, from the Canelos Quichua perspective of "our" culture and "other" cultures. Figure 1 illustrates how, from Canelos Quichua perspectives, knowledge of "our" and "other" are forever juxtaposed.

Here we find the centrality of the *yachaj*, "one who knows," who is a powerful shaman if male, master potter if female. Such knowledgeable ones attain a level of control that enables them to balance experiential knowledge with cultural knowledge and to integrate them with their visions and their reflections. Women in Canelos Quichua culture work with clay, rock and clay dyes, fire, and oxygen (conceived of as "breath"). Their art is guided by the very concepts and culturally conceived force fields that undergird shamanic control. The designs on their polychrome pottery link cosmic networks to everyday events, the general to the specific, the ancient to the present, the mysterious to the mundane.

While contemporary Canelos Quichua women make ceramics for their own domestic and ceremonial use, many of them also sell their wares to the ethnic-arts market to augment their family income. They are joined in this economic enterprise by their husbands, sons, fathers, and brothers. From a modest beginning in 1975, Canelos Quichua men have developed a thriving

wood-carving industry, and national and international sales have increased enormously since 1980. Tradition formed the basis of men's knowledge of woods, their skills in carving and in several prominent designs, but modern economic pressure gave the impetus for large-scale production.

Figure 1:
Concept of *Yachaj*

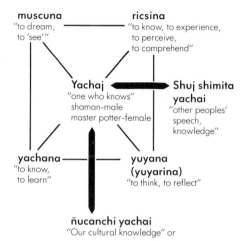

muscuna
"to dream, to 'see'"

ricsina
"to know, to experience, to perceive, to comprehend"

Yachaj
"one who knows"
shaman-male
master potter-female

Shuj shimita yachai
"other peoples' speech, knowledge"

yachana
"to know, to learn"

yuyana (yuyarina)
"to think, to reflect"

ñucanchi yachai
"Our cultural knowledge" or

Ñucanchi ricsiushca Runa
"Our people's perception"

Ethnic Art

From antiquity into present times, all Canelos Quichua men have skillfully made utilitarian products. They build their own homes, make canoes and paddles, and carve large bowls and pestles for pounding manioc and flat boards for rolling clay and cutting tobacco. In June 1975, Segundo Vargas saw two examples of Ecuadorian tourist art. Within two weeks he had carved an agouti and a caiman from the same moderately hard wood used for canoes and stools (seats of power). Other men in the Puyo area saw Segundo's work, and many of them began to experiment with wood carving. Soon a variety of birds and animals were being made, some from hardwoods but more from balsa.

Most of the early carvings were unpainted, though some men experimented with colors, using traditional plant dyes, various commercial paints, and even Kool-Aid. As the men became more skilled in carving realistic and whimsical forms and burning decorations on them, Joe Brenner, a North American then living in Puyo, discovered and developed techniques for staining and lacquering balsa. The brightly colored jungle birds caught on quickly in the national ethnic-arts market, communicating something of tropical forest vibrancy to an international community of collectors, and the demand for them steadily increased.

Two nuts from forest trees from which, it is said, monkeys drink during their festivals. Top, wild cacao; bottom, a wild zapote-like fruit
Theresa Santi

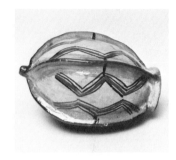

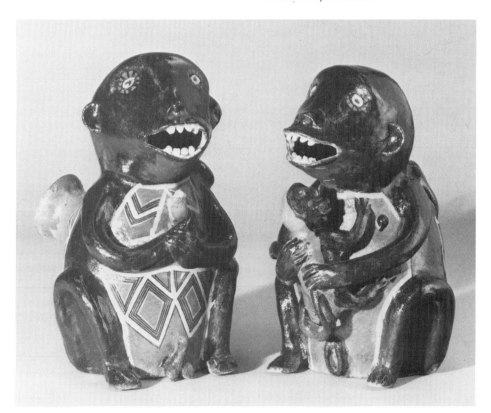

Monkey couple, with the male holding a "monkey calabash"
Esthela Dagua

In their carving, Runa men play with the forces from outside their culture, just as they do in the annual ceremonies. Their own skills and powers to create beauty and humor come from within, and their products go out from them for a fair return in money so necessary in today's capitalist economy. The imagery presented to the outside world by Puyo Runa men is drawn from the carvers' deep knowledge of their own cosmology and ecology and is enriched by the shamanic knowledge transmitted by men and by the ceramic knowledge transmitted by women. Reciprocally, some women have drawn from the new ethnic-arts market carvings to enlarge their own repertoire of ceramic figurines.

The most engaging and popular carving is that of the toucan, traditional symbol of liberation. The stylized version, originally carved by the Watatuca brothers, was quickly adopted as a logo by two of the most prominent dealers in ethnic art in Quito.

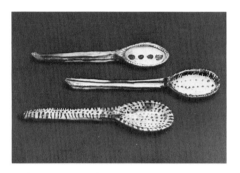

Spoons
Victoria Santi

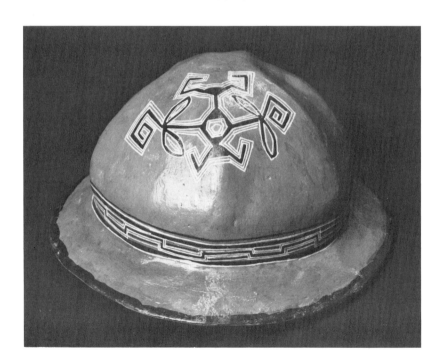

Malaria worker's hardhat
Apacha Vargas

Ceramics are an ancient, totally indigenous form of traditional art. The growth of the balsa ethnic arts, however, depends in large part on caustic wood stains imported from Germany and in part on burning and painting techniques developed by an outsider, Joe Brenner, and elaborated from within by many indigenous people. In traditional Canelos Quichua life, beautiful handmade items, not currency, served as a medium of exchange. A headdress, a fine bowl, or a beaded necklace might have been given to a strong shaman for his wisdom in curing an illness.

Today traditional ceramic art and new ethnic arts of the Canelos Quichua people are in keeping with the heritage of relating beauty and knowledge to continuity and change. The wood ethnic arts, in particular, have become an important source of income for many households, allowing financial independence in a world of increasing cash demands. This ability to create beauty through knowledge yields financial independence, and hence the promise of power to control their own lives, to loosen, or even cut, the bonds of foreign domination.

The exhibition for which this book was prepared juxtaposes traditional art forms, which draw upon ancient cosmological beliefs, with current, ongoing innovation encouraged substantially by the ethnic-arts market. In both this book and in the exhibition, we describe premises and structures of an ancient logical-aesthetic foundation to emphasize the deep meanings embodied in new configurations. The old and the new are imbued with imagery derived from a thorough ecological knowledge of Amazonian systematics and dynamics. Descriptive material in the exhibition and in this book is based on salient, indigenous concepts of power, beauty, strength, and value that signify critical dimensions of the core of a cultural system that has had scant recognition since Orellana's time. Some of these basic concepts that link ecological knowledge with cosmological premises and the knowledge of mythic reality are now set forth.

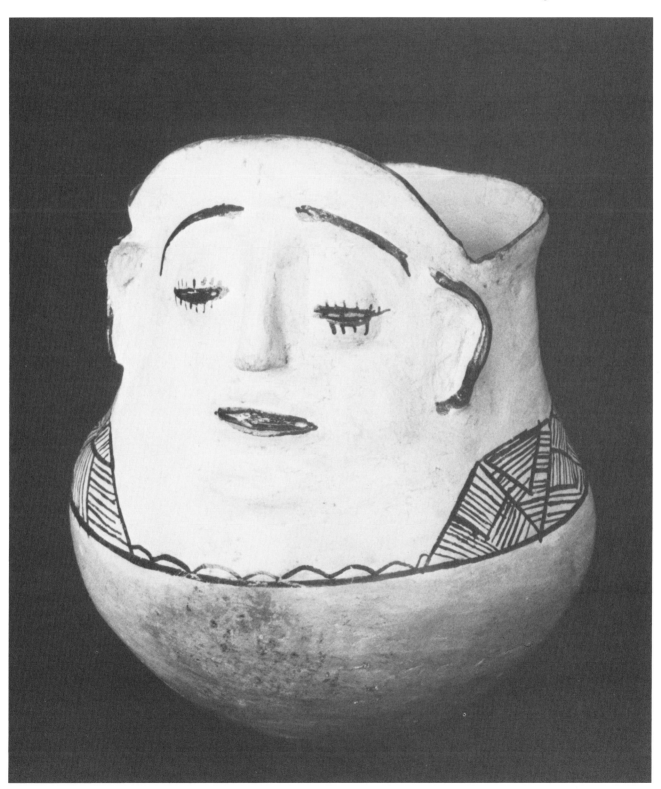

Sicuanga manga with face of
master spirit of garden soil and
pottery clay
Lucilla Dagua

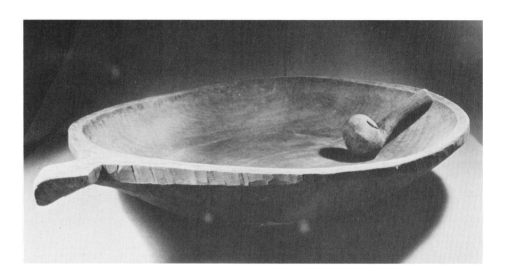

Large bowl with turtle head, for
pounding cooked manioc into a
mash used in making *aswa*
Marcelo Santi Simbaña

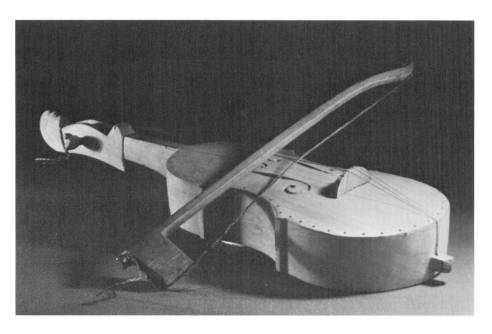

Violin

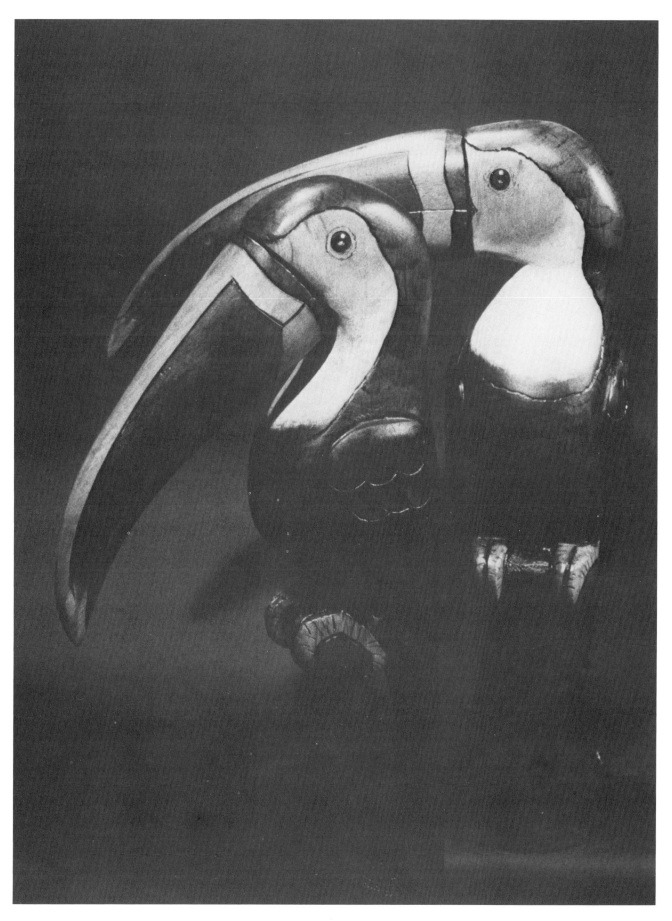

Toucans, 1984
Segundo Vargas

Imagery and Power

The concept of *transformation* undergirds the cosmological and ecological knowledge of the Canelos Quichua. As one learns to plant, raise, harvest, and process crops for food, and to gather food products and utilitarian products from forest and river, one also acquires an expanding knowledge of the dynamics of tropical rain-forest and riparian ecosystems. What a person learns in an experiential manner reveals something of the structure of life, society, nature, and the cosmos. The growing and questing Runa comes to understand transformational processes of birth and death, growth and decay, decomposition and regeneration, and the various biological mechanisms of metamorphosis. Similarly, when a Runa gleans knowledge of the spirit world from a shaman, s/he learns of animate essences of inanimate substances, of spiritual essences that may be acquired by

human beings, and of the transformations that permeate these and other spheres of social existence. Runa learn that order exits and prevails even in the midst of chaotic change. As a person seeks to establish order in one realm of life, s/he draws information from another realm, thereby effecting a clear consciousness of transformation as the basis of all continuity and change.

Time-Space

Time-space must be regarded as a unity, not as the discrete entities "space" and "time" of Euro-American thought. Time-space has epochs characterized by events, both of which involve transformations of people, objects, spirits, and beings that occur discontinuously. Everything that happens occurs in a distinct time-place, and each time-place provides a key reference marker for the other. The Amazon rubber boom of the late nineteenth century, the search for oil in the 1930s, the Peruvian invasion of Amazonian Ecuador in 1941, and renewed petroleum exploration in the 1960s and 1970s each mark a special epoch that is altered according to the actual locations affected. Festivals, too, mark time-space for participants, as do journeys. In relating a story, the narrator tells the audience when and where the event is set. The Canelos Quichua characterize time-space by descriptive phrases, such as Old Times, Times of Destruction, and Times of the Ancestors, and they place events in specific time-space. The effects of events within temporal periods in given places are brought into individual or collective indigenous historical consciousness as a part of various renderings of the past. In addition, Runa have a strong sense of mythic and legendary time-space, by which they color and animate their historical and topographical consciousness.

Unai, Mythic Time-Space, refers to that which came before the Beginnings. In *unai* everything possessed the sentient qualities that we today regard as "human." All celestial bodies, trees, animals, rocks, spirits, souls — everything — walked upright and visited with one another from house to house, just as people do today. People themselves were immature babies; they crawled on all fours and spoke only in two tone hums: ^{mm}mm / ^{mm}mm. *Unai* is always with us. It exists in the present and will continue into the future. It is

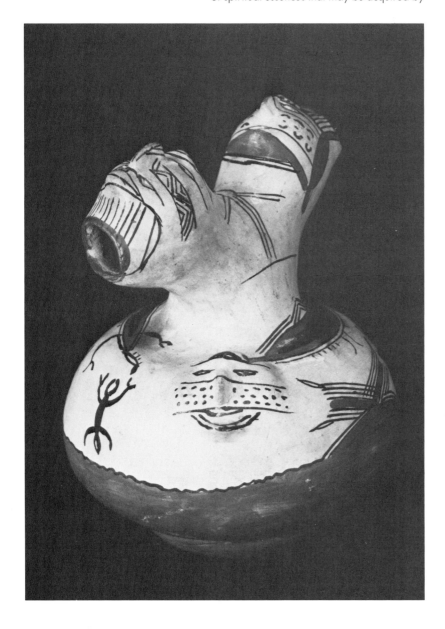

the source of mythology, of visionary reality, of some dreams, and of enduring tradition.

Callarirucuguna, Beginning Times-Places, embraces the period of transformation from *unai* to the Times of Destruction and the Times of the Ancestors. Every episode of Beginning Times-Places may also be brought into the present, as it is brought into consciousness symbolically by the combined processes of learning, knowledge, thought, and vision controlled by powerful shamans and master potters. *Callarirucuguna* is the combination of legend and history transformed by myth and experience. For example, after a shaman has drunk his soul-vine brew, he may call on the spirits of fallen Peruvian soldiers, who come to him in the form of downriver otter-people, dancing as festive humans with toucan-feather headdresses. The Runa say of these two structures of space-time:

Ñucanchij callarirucugunata cuti yachashpa,
unaimandata cuti yachashpa.
Learning again from our mythic time-space,
we are knowing once more our
beginning times-places.

Souls and Spirits

Aya, in Amazonian Quichua, means "soul," and it may or may not be associated with death and the dead. A soul is the essence of a fully human being. It comes to human babies through birth from a fully human woman whose fully human male egg has been placed in her by the father. "Fully human" means that the soul is *of us* (Runamanda); it is not of the spirit world, nor the animal world, nor the foreigner's world. In addition to inheritance, the essences and substances of one's soul are acquired idiosyncratically through individual questing and collectively through closer links with the ancestors of one's kith and kin.

Spirits also have souls, which may be conjoined in various ways with the soul substances of a developing Runa. Indeed, the bonding of soul, ancestor, and spirit essences shapes the structure of soul substance of dynamic humanity within each Runa. Although all beings have souls, potentially at least, the nature of the truly human soul is subject to thought and reflection. It is not automatically believed that all "people" who speak "languages" have fully human souls. Human and spirit souls may exist in what Westerners take to be inanimate objects, especially in sentient stones. Souls and spirits are imparted to ceramics by master potters and to spirit objects by powerful shamans.

Supai, in Amazonian Quichua, means "spirit." Usually a spirit is inanimate and its appearance to a human takes place when either spirit or human or both have moved from one plane of existence to another. Spirits may take the form of human beings, of animals, and sometimes of

Unaimanda. (Opposite) This pot represents many dimensions of Mythic Time-Space. The serving spouts, the two raised faces and the aquatic life designs symbolize ancient concepts of duality: forest spirit/human spirit; sun and moon, day and night, order and chaos; and living humans and water spirit people.
Alicia Canelos

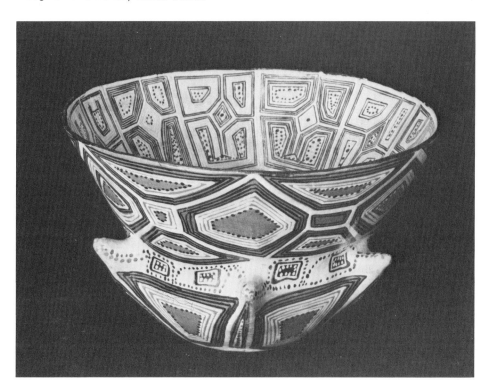

Tucuna. The form of this *mucawa*, made for a human festival, may be interpreted as a star or as a forest nut. As the first, it symbolizes the transformation of a fallen star into a beautiful woman, and so represents ancient mythical and legendary ancestors of contemporary people. As the second, it represents nuts used by mythical monkey people (later transformed into almost human monkeys) in their tree-top festivals.

Left, spirit master Sungui; right,
his soul
Apacha Vargas

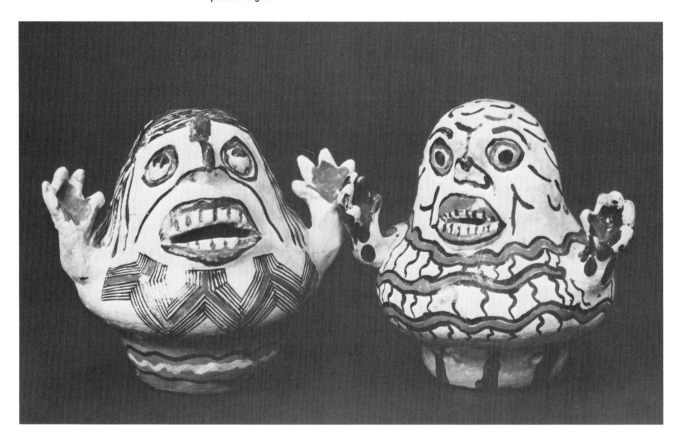

demons. Foreign people, for example, are
considered to be *machin runa*, monkey-
people, and their souls are thought to be very
poorly developed. It is also said that the ter-
ritories of the *machin runa* are overseen by a
dangerous and fearsome foreign spirit mas-
ter, Hurihuri, a transformation of the Runa
forest spirit Amasanga. Hurihuri is danger-
ous, domineering, and to be feared. But this
powerful *supai* is part of the Runa universe,
just as are those of weak souls, the foreign
monkey-people, who seek always to dominate.

Forest and Garden

Sacha means "rain forest" in the Quichua of
Amazonian Ecuador. It does not convey any
of the sense of "uncivilized, untamed land"
found in contemporary Andean Quichua and

in non-Quichuan thought. *Chagra* is the swid-
den garden of the lowland moist tropics.
Sacha contrasts with *chagra*: the first domain
is "natural," the second "cultural"; each is a
transformation of the other.

Forest and garden are complex,
contrasting, yet interrelated systems unified
by basic ecological and cosmological princi-
ples that are well known to Canelos Quichua
men and women. Men cut trees and trim
vines and bushes to remove a segment of the
rain forest. This is an act of predation on
the forest; it is a radical alteration of nature.
Restoration is made by women, who plant
domesticated manioc and other earth vege-
tables. The planting is not done in the poor
tropical soil itself but in what women call
chaquichishca panga allpa tucungawa (leaf
litter changing into soil). As the original swid-
den garden grows, its domesticated crops
become increasingly diverse. Women add
more earth-vegetable crops such as taro and
sweet potato for home consumption, and
men begin to plant maize and plantains for

household consumption and to sell. At the same time, plants, trees, and vines of the adjacent forest invade, and birds and animals deposit a myriad of wild nuts and seeds in the garden.

The forest abutting the *chagra* is cleared further by men, and sections of the *chagra* are allowed to lie fallow. This cutting and fallowing is called "shifting cultivation," or "swidden cultivation." Eventually such shifting ceases and the swidden agricultural plot is allowed to grow back to forest. In up to twenty years or so, the domesticated plants, feral plants, and wild plants of the *chagra*-second-growth forest reach a point of great diversity. The area is neither garden nor forest; men and women cease to clear or weed it.

The abundance of wild, feral, and domestic plants attracts many animals, which are hunted by men who bring their system of predation back into the area previously domesticated by women. The complementarity of male predation/female domestication corresponds to the *sacha/chagra* transformational system. An understanding of these relationships is part and parcel of indigenous ideas about nature and culture and how this overt dichotomy actually dissolves through ongoing systems of transformation manifest in the biosphere.

Such an interplay is symbolized socially by the Canelos Quichua as a parallel system of cultural transmission: women to women through the medium of ceramic manufacture; men to men through the medium of shamanic performance. Specifically, male shamanism is a transformation of predation on nature to predation on spirits (healing) and humans (making sick), while female ceramic manufacture is the transformation of domestication of food to the domestication of beauty.

Chthonian Power

All peoples everywhere conceptualize power in various dimensions ranging from the crushing force of political-economic domination and cultural hegemony imposed by modern nation-states to the inner power of individual strength used to overcome barriers that are part of everyday life. In the Andes and in Amazonia, one of many dimensions of conceptualized power may be described as

"chthonian." Chthonian comes to us from the Greeks, who used the term to refer to gods or spirits of the Underworld, as opposed to those of Olympus. South American native peoples have strong concepts of underearth that are also "within" the earth, or within earth within water.

To understand the ultimate spirit force in Canelos Quichua culture, conceptualized as the sentient spirit master Sungui, we must now turn to the all-embracing being of a dynamic, dramatic, and fearsome universe. We refer, of course, to the mighty anaconda, called *amarun* or *amaru* (hereafter, *amarun*) throughout the Quichua-speaking world of the Andes and Amazonia. Most, if not all, Andean and Amazonian peoples conceive of the anaconda as a source of ultimate inner power — chthonian power — collective and individual power from "within" that generates abilities to resist hegemony. The Canelos Quichua regard the continuity of the kinship system, which emerged in Beginning Times-Places, as intimately connected to the appearance of the *amarun* in all rivers, streams, oxbow lakes, and rivelets of Amazonia. The *amarun* is master of fish and spirit master of the *yacu supai runa*, the river-spirit people analogous to the humans of land. Mythically, humans and the *amarun* share a common corporeal substance. The *amarun* is to the water world what the male human is to his household and to his family: the primary procreator.

Sungui is the spirit master of the water domain — not just the lakes, rainfall, and rivers but also of all the water encompassing the world, the hydrosphere. Sungui is androgynous, and in his male form he is first shaman, or beginning shaman. As spirit master he comes to the forest-spirit shaman

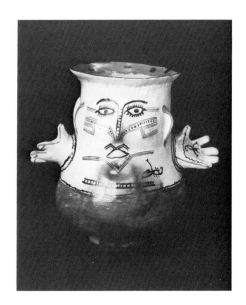

Sacha Runa/Sacha Warmi. This pot has two sides, both with faces. On one side is the face of the spirit master of the rain forest, Sacha Runa; on the reverse is that of the woman spirit master of the rain forest, Sacha Warmi. Such duality is common in Canelos Quichua aesthetics. It represents, among many other things, the system of parallelism in transmission of culture, men to men through the shamanic tradition, women to women through the ceramic tradition.
Filomina Santamaría

(Amasanga) and to human shamans as *yacu mama*, black anaconda. As "one who sees," Sungui often appears to a human shaman as a beautiful fish-woman. As a shaman, Sungui sits on the Amazonian river turtle, *charapa*, his seat of power. S/he dresses in rainbow colors with a predominance of red and yellow and appears in the atmosphere as the rainbow. When hunting to kill, in the water or on land, he moves as the rainbow-colored, red-spotted, chthonian anaconda. Sungui may also appear to humans on a riverbank as a naked, white-haired man with very pale skin. Sungui's forces must be controlled, for his power, if unleashed, could end everything. Control systems include those of spirits and humans.

Destructive force is linked to Sungui as torrential rains promoting flood, erosion, and landslide. Within his water world live many denizens from which human powers are descended. These are the *yacu apawais*, or ancient water dwellings. All have external skeletons, ancient signs of the Asiatic-New World shamanic complex (Furst 1977). Something of human flesh is enclosed in these skeletal dwellings of living hard-shell beings, including armored catfish, shrimp, crabs, and helgramites. Their powerful, evocative imagery is controlled by women, who draw images of them on ceramic bowls and make effigy bowls in their forms. These feminine representations of early shamanic power are controlled, to some extent, by male shamans.

Shamanic Gnosis

The ancestral *yachaj*s of the historical and contemporary Runa experimented with plants and came to know some of them as delicately powerful sentient beings and forces of the spirit world. Two such plants, called *ayawasca* (soul vine) and *wanduj*, provide chemical

means by which Runa open portals to the spirit world, pass through these portals, interact with spirits there, and return to their own world. Both of these plants are powerful hallucinogens, and the latter is especially dangerous.

Ayawasca is of the virgin forest, and though it may be planted, it remains *sachamanda*, from the forest. It must be drunk within a shaman's house at night, and the house must be thoroughly darkened. Shamans take their soul-vine brew to diagnose illness, and patients and onlookers as well often take the special brew (prepared by a shaman) during a diagnostic and curing seance. This brew may also be called "moon-vine," recognizing the chaotic movements of the moon and the everlasting uncertainty that Moon's erratic movement creates in night skies.

Shamanic seances are tranquil, but they represent chaos. The shaman mentally "comes and goes" from the site of the seance to other places, and spirits "come and go" from their sites to visit him as he sits on his seat of power. Aided by his soul vine, the shaman figuratively appropriates the order of the universe, pastes together a montage of palpable images drawn from the Canelos Quichua concepts of "our culture," and "other cultures," and repositions patient, audience, and agencies of illness in the new construct of "our order."

Canelos Quichua mythology and legend do not tell us where *wanduj*, the powerful datura, was first found, but soon after its discovery all indigenous people planted it in their swidden gardens. Datura today and through history is from the garden, *chagramanda*. It must be taken in the forest (for men)

Left, depiction of shaman on his seat of power, as the image of Amasanga appears.
Right, Amasanga spirit in a tree
Alfonso Chango

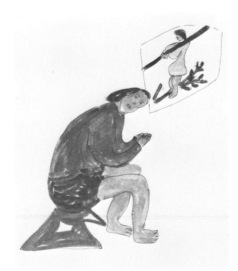

34

Hurihuri supai: a fearsome
spirit of other people's territory
Rebeca Hualinga

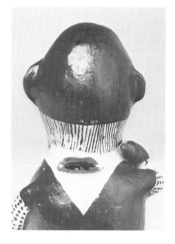

The back of the same Hurihuri
supai figurine showing
the teeth growing out of the
spirit's neck

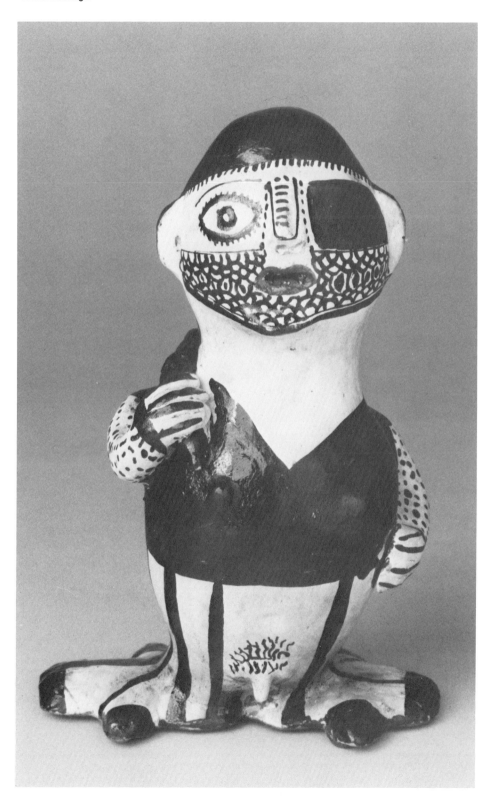

Machin runa: a North American
oil boss made in the form of an
edible gourd
Clara Santi Simbaña

or in the swidden (for women) during the day so that the trip through the spirit world begins at noon. The taking of *wanduj* begins with death. The questing Runa is removed from the world of humans and passes directly into the world of spirits. The ensuing curing trip is overseen by a spirit shaman of the forest.

The datura trip itself is violent and terrifying, but it is represented as an ordered system of new insight whereby the person who takes the trip reorders not only his or her own universe but the cosmos of others as well.

Conceptually, *wanduj* is prior to *ayawasca*. One cannot learn to "come and go" from the quotidian world to the spirit world and back with the vehicle of *ayawasca* without first traveling alone to the spirit world to be guided within it and back out by a spirit shaman. The use of *wanduj* and *ayawasca* by people of Canelos Quichua culture takes the users, their families, friends, and other associates far into the worlds of "others" — other humans, other spirits, other animals,

other beings, other places. They pass, at times, especially when on a datura quest, over the threshold from life to death and then back from the spirit world to human activities.

Shamanic Practice
After drinking his soul-vine brew, the shaman sits in seance on a carved wooden stool that represents the Amazonian water turtle. Spirits come to him: first Sungui, as anaconda or spirit fish; then Amasanga, as black jaguar. The shaman also visits spirits. He stands, encountering them on their seats of power, and he returns to his own seat of power as spirits come to him. As he establishes his power upon a given spirit force, he himself becomes the seat of power of a spirit.

To diagnose illness the shaman shakes his leaf bundle, evoking the vision of flickering snake tongues among those who have taken his soul-vine brew. He also calls on ancient powerful shamans and spirits believed to live within special stones. The shaman clarifies his vision by snuffing tobacco water, prepared on a carved wooden turtle plank by his wife or daughter.

Yacu apawais: crab
Apacha Vargas

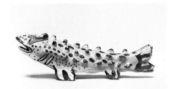

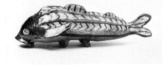

Two representations of fish
Esthela Dagua

Yacu supai runa: the fish people, with the *charapa*, Amazonian water turtle, seat of power of the water spirit master, Sungui
Esthela Dagua

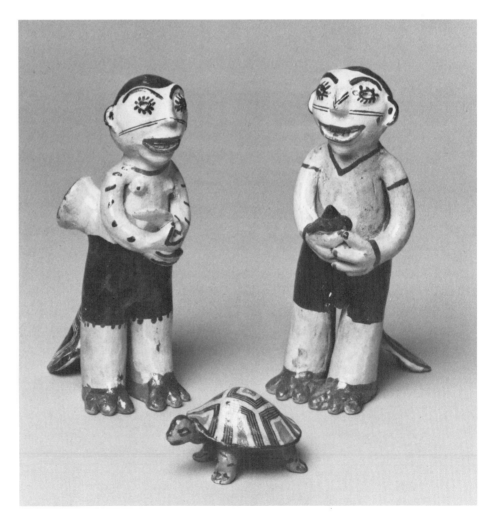

As inchoate images appear to him he softly describes the feelings and sensations they evoke. His wife or daughter snuffs tobacco water and then clarifies the vision for the shaman by naming it, speaking as though the vision itself were speaking: "I am black jaguar"; "I am black anaconda."

Sources of Power

The concept of shamanic control of spirit substances takes us to *control of nature*. Sungui, the first shaman and the ultimate source of power, is forever on the brink of throwing the world out of control. Amasanga is imbued with abilities to control rain-forest dynamics, and by such control the universe stays relatively ordered. Amasanga contrasts with Nungwi, who controls domesticated plants, as well as with Sungui. The contrasts may best be thought of as encapsulating spheres, each inner sphere domesticating or controlling aspects of the environing sphere, as in Figure 2.

Figure 2

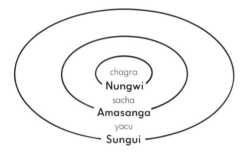

Powers to control external forces come from within the spheres. The important Canelos Quichua concept for "within" is *ucui*. The inner self of the fully human Runa contains a life force, *causai*, which is expressed collectively as "our culture," *ñucanchi causai*. It also contains a fully developed soul, *aya*, which lives on after the flesh is dead. Ancient shamans, it is said, directed their souls to areas within rocks and trees, from which ancestral Runa acquired them, assuring continuing inner powers down through historical and contemporary generations.

Shamans acquire spirit helpers that come to reside in purple mucous inside hard shells within the shaman's inner will, called *shungu*. These spirit helpers are analogous to the *apawais* that live in the external water worlds. By portraying such imagery in ceramics, women give palpable form to shamanic imagery, just as the shamans, in seance, bring

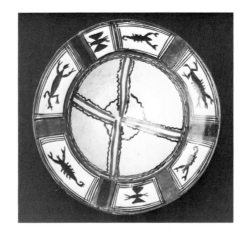

Drinking bowl with *yacu apawais* around rim
Alicia Canelos

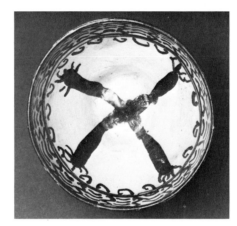

Two *mucawas* with datura (*wanduj*) icon inside. The one below has two symbols of power, one inner (the *wanduj*) and the other external ("Mobile special").

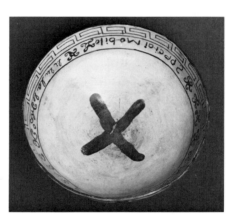

from within their wills imagery that the women not only "see" but also "clarify." Two natural environments that contain living beings, thought to be sentient by the Canelos Quichua, are earth and water. The ultimate inner power, a veritable chthonian one, comes from within mire within water: this is the domain of the anaconda, the corporeal manifestation of the first shaman, Sungui.

As a shaman sings his spirit
song, spirit bees come to him,
often appearing as flickering
sparks
Alfonso Chango

Shaman talking to Yacu mama,
as spirit fish. As the shaman
gleans knowledge from the
master of the water domain, he
swells physically
Alfonso Chango

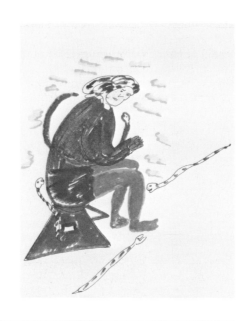

The Canelos Quichua balance con-
cepts of the ethereal with the tangible. For
example, a man who senses beauty within
himself can prove its existence by playing a
flute or by singing. The melody and the sung
or unsung words come to him from the spirit
world and pass outward on his breath, which
carries with it something of the invisible, yet
tangible proof of inner strength. Tangibility,
and thereby proof, is achieved when those
receiving the melody reflect on the evocative
imagery and comment on their reactions to
shared perceptions. When a song that should
make one happy does so, or when (more
frequently) a sad song communicates to the
listener genuine melancholy, tangible "proof"
again has been made on the strength of one's
breath, as a mediator between the spirit
world and the inner world of the singer or
flute player.

When a woman makes pottery she
must control the hot breath of the fire. As heat
leaves a pot after firing, it alters the normal
air currents and viscosity. If the potter does
not control heat, the fire's breath will cause
the vessel to crack or burst as it cools. The
completed pot is "proof" of her ability to
control the elements that go into the mastery
of ceramics. Wind that comes from a hill, or
from within the forest itself, has its own term,
waira, but it is also known as the breath of
the hill, or the breath of the hill spirits, or the
breath of the forest spirits, or a combination
of each. When a shaman diagnoses and
cures, he draws on such wind in his special
leaf bundle. And when women make
ceramics, they call on various forest and hill
winds to guide the rain clouds away from
their work zone.

Within the Canelos Quichua world
there are dangerous forms of blowing, as
when one expels a magical dart, and normal
forms of blowing, as when one blows a nor-
mal dart from a blowgun. There are also
shamanic "proofs" of inner power manifest
after death in the form of "congealed breath"
that appear as snails leaving a tomb. Such
manifestations may be represented by women
in their ceramic manufacture.

Ceremonial Enactment

The concepts of transformation are depicted
in arenas of external force and inner power
during a festive ceremony enacted annually

by the Canelos Quichua. Enactment takes place only in hamlets with a Catholic church or chapel, where the chaotic and destructive outside foreigners' force and inside native power may merge. All facets of Canelos Quichua cosmology discussed above are enacted for three days and nights, as celebrants pass back and forth from the male festival house (ritual enclosure of Quilla, the roguish moon) to the female festival house (ritual enclosure of Hilucu, Moon's sister-lover, the whippoorwill-like Potoo bird). The ceremony ends with a powerful and palpable ritual reversal. In this enactment, which the Canelos Quichua call Dominario (from the Spanish *dominar*, to control), the mighty, chthonian mud anaconda is brought from the water to move dangerously and terrifyingly on the land.

In Canelos Quichua thought, the anaconda comes on land only to devour humans or their game animals. In the Dominario, the anaconda, corporeal representative of master spirit Sungui, is borne on the backs of four men who represent jaguars, corporeal representatives of Amasanga. Instead of

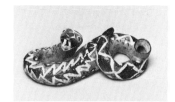
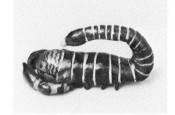

Shamans not only heal, they also send illness by blowing magical darts at their enemies. These two ceramic pieces represent shamanic attack. Top, a tropical forest rattlesnake; bottom, a scorpion.
Apacha Vargas

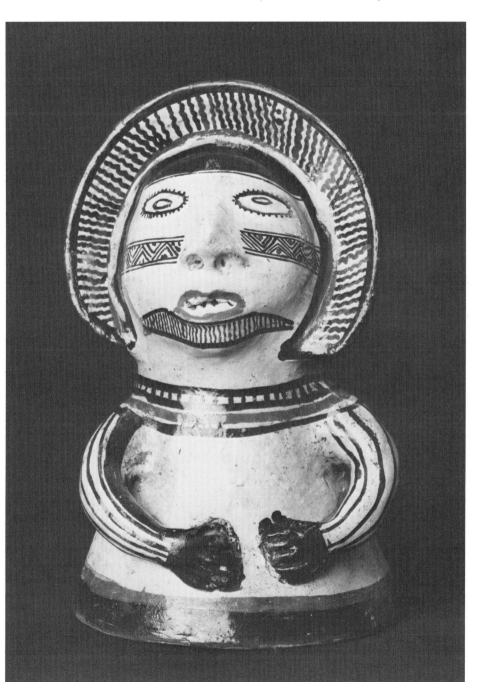

Nungwi, as spirit master of garden soil
Rebeca Hualinga

controlling Sungui's domain (the hydrosphere), Amasanga releases powers enclosed within it. Instead of the externally imposed social control represented by the church, indigenous power becomes an embodied apotheosis of stylized resistance.

As the four men come forth bearing a bamboo pole with four copal fires burning within it (the stylized anaconda brought from the water), festival participants begin dancing through arches constructed for the Catholic mission. Then the transformation, *tucuna*, begins. The pole, as *amarun*, Sungui's corporeal form, is carried in a lurching, going-out-of-control manner that becomes destructive. The bearers and the pole crash right into and through the church, slamming, falling, rising again, running, frightening everyone, completely out of control in their destruction of the embodiment of external domination.

Acting against cultural hegemony within a setting of Western domination, the festival reaches a crescendo that is, quite literally, terrifying to the participants. Women dance with their hair flying to and fro, their stylized, sideways motion of hair throwing being the analogue of the male-performed two-tone hum ($^{mm}mm/ ^{mm}mm$) of shamanic chanting that evokes the imagery of mythic

time-space (*unai*). Men beat snare drums, circling and circling while producing a resonating pulse-tremolo that signifies Amasanga's rumble of approaching thunder. All souls and spirits and beings are indiscriminately summoned.

As escalating chaos reigns, the chapel is said to be destroyed in one great transformation of the world of forest and garden and earth and mire into an encompassing, rushing, surging, eastward-flowing sea. When performing the stylized activities that signal this event, the Canelos Quichua say that they fear *tucurina* (which derives from *tucuna*, transformation, and means "ending everything"). The concept of *tucurina* is one of the most powerful ones in Canelos Quichua thought, particularly when applied reflexively to one's own group. It means, in this sense, that to truly destroy the dominating authority of the church by the invocation of the ultimate power of Sungui, as devouring, chthonian anaconda, the Canelos Quichua may also destroy themselves, embedded as they are — in a revelatory manner through the vehicle of this ritual — in that very domination.

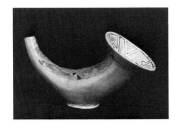

Cornet made for a festival in Quillu Allpa (near Curaray) Eluisa Santi

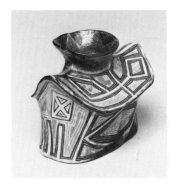

Ceramic representation of the chapel at Curaray, penetrated by the jaguar-borne anaconda Inez Padilla

Festival effigy pots: giant anteater dancing with jaguar the late Soledad Vargas

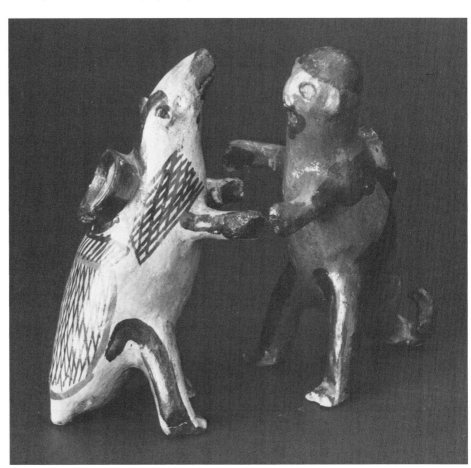

Drum
René Santi

Traditional shamanic seat
of power in the form of an
Amazonian water turtle
the late Acevedo Vargas

Carved wooden stool in the form
of a jaguar, made for the ethnic-
arts market. This represents
both the seat of power of a pow-
erful shaman and the powerful
shaman, as jaguar, standing
before spirits as they sit on their
seats of power.
Antonio Vargas

Imagery and Creativity

Transformation, *tucuna*, and related ideas synthesize many of the complexities sketched earlier with regard to the enduring dimensions of Runa cosmology. Spirit masters Nungwi, Amasanga, and Sungui all have important transformations. For example, the two principal transformations of feminine spirit Nungwi are Chagra mama, spirit of the swidden, and Manga allpa mama, spirit of pottery clay. Amasanga, as we have seen, transforms to Hurihuri, dangerous spirit master of other peoples who reside in other territories. Amasanga has many other transformable images as well, each of them contrasting with the original being. Two important transformations of Sungui are to Yacu mama, the black anaconda who visits the shaman in seance before he begins to "see" and discusses imagery with him before he gains the powers necessary to heal, and to the man-eating "mud anaconda" that lives within mire within water.

In Canelos Quichua mythology and legend, transformations occur in actions and events, in levels and nature of existence, and in the names and qualities of characters. Sometimes myths begin with a visit of one being to another; for example, a star falls to earth, becomes a beautiful woman or a lost brother, and interacts with a human before transforming into something or someone else. Commonly, within a tale, two brothers or two sisters are traveling together and, as they walk along a trail, abrupt transformations move the story from one time-space to another, from one set of ideas to another. Transformations also occur among common characters: the moon may become a star;

Hilucu may become Nungwi. In such transformations the text shifts from one story to another so that a spiraling effect is created. No story ever really ends. When expert tellers are involved, they may come to the point where they tell the listener that if s/he wants more of a given story, s/he should learn Achuar or Cocama or Záparo and go live with other people for a time.

Common elements in mythic and legendary storytelling include the journey itself and its constant interruption due to unforeseen events, often brought about by foolishness due to lack of knowledge. Houses in the tales are mythic and legendary domains that have their own form and order. Natural places such as rivers, rocks, and trees are also mythic and legendary domains where traveling Runa find themselves after a mishap; they may be placed there, for example, by a hawk or a condor, and they must find a way to escape. Indigenous legends of the Canelos Quichua abound with adventures in different times and in different places, all to become part of their enduring cultural history. Through these adventures Runa say that their legendary and historical ancestors learned individually; eventually, as they reunited in a formative period of cultural persistence, the knowledge that was transmitted from generation to generation became an enormous corpus of historical awareness to be applied to the immediate past, the present, and the future.

Ecological Imagery and Indigenous Cosmography

Amasanga, Hurihuri, and the Origin of Territoriality

In *unai*, Amasanga (male) and Amasanga warmi (female) were fully human beings who walked on the earth, just like people do today. In *callarirucuguna*, Amasanga became a master spirit; the rain forest, including the weather, became his dominion. He became Amasanga supai, an androgynous being of the forest who dressed in iridescent, shimmering blue-black. He carried a blowgun and quiver and was accompanied by the bushdog as his mascot. He was forest shaman who sat on a tortoise seat of power or on a forest iguanid seat of power. As spirit of the datura, Amasanga would oversee visionary

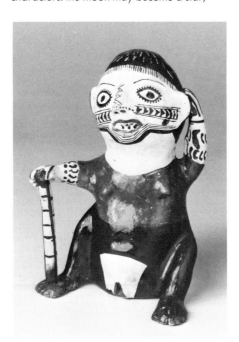

Nungwi, as spirit master of pottery clay
Rebeca Hualinga

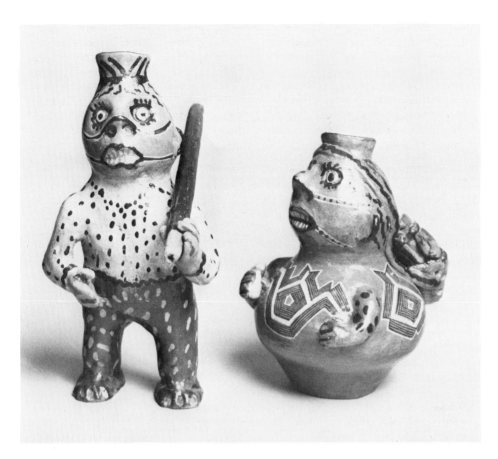

Left, Amasanga; right,
Amasanga warmi
Apacha Vargas

Iguanid, Amasanga's seat
of power
Santa Hualinga

Jaguar, Amasanga's corporeal
representation
Rebeca Hualinga

Bushdog, mascot of Amasanga
Theresa Dagua

experiences of lone, questing Runa; and he would also oversee the course of predation of rain-forest game animals and game birds by males in his territory.

As the Beginning Times-Places progressed, Amasanga and Amasanga warmi underwent another transformation. They, as androgynous beings, became increasingly associated with the high regions of the forest rather than with the ground. As the association of Amasanga as a being who walks along tree limbs emerged, Amasanga and Amasanga warmi also began to transform into a fearsome, underearth, androgynous spirit, Hurihuri supai. From the standpoint of Canelos Quichua tellers, Amasanga, as a being associated with "our" forest and "our" game animals, is simultaneously transformed into Hurihuri, a being associated with the underearth.

Hurihuri became an underearth spirit of *other people*, of the monkey-people, the *machin runa*. Teeth grew from a mouth that developed in the back of Hurihuri's head (or neck). With his front mouth he would eat monkeys, just as humans do; with his back mouth he would eat humans and all beings that smelled like humans. The Beginning Times-Places divided Runa territory, overseen by Amasanga, from other peoples' territories, associated with monkey abundance and

overseen by the Hurihuri master spirit. Human territory and foreign territories abutted one another, and each produced dangers for the other.

Nungwi and the Origin of the Amazonian Swidden Garden

Nungwi, sister of Manduru warmi (red woman) and Widuj warmi (black woman), was walking in the forest with her daughter (who may also in some variants of this myth be her sister), Hunculu. Three men wanted to marry this daughter — Quindi (hummingbird), Acanga (hawk), and Sicuanga (toucan). "Which is the best worker?" wondered Hunculu. The women heard the sound of falling trees and much laughter in the forest, like a mighty worker clearing and clearing, and they saw Acanga on top of a hill picking up great rocks and heaving them into the forest, laughing all the while. The crashing and banging of boulders sounded just like the felling of trees. Nothing was being cut or cleaned by Hawk, though; nothing was domesticated and brought to the use of humans. The forest was just being aroused.

Right, Nungwi as spirit master of garden soil with toucan-feather headdress; she is blowing on Hunculu with her magical breath, creating her present corporeal form as a frog. Left, Hunculu; center, Nungwi as a small snake created by Hunculu.
Nungwi: Theresa Dagua;
Hunculu: Esthela Dagua;
snake: Esthela Chango

Later the women came to an area that Quindi had cleared of trees, where the sunlight was bright on the leaf litter that covered the forest soil. "With this sunlight manioc will grow," said Nungwi, "but we must learn to know it, and to plant it." Hunculu said to Nungwi, "How can we plant such an enormous *chagra*?" "Now we'll get a stick of manioc," Nungwi replied, and she and Hunculu got lots of sticks, piles of them. Nungwi painted them red with *Bixa orellana* and then painted her own face with the color of her red sister, and in that way the manioc and Nungwi "knew" each other. Without this relationship of knowledge, the manioc would suck the blood of anyone who tried to control the plant's growth. Nungwi began to dig with her palm-wood *tula*; she dug and dug, working steadily in the leaf litter and upper soil, until she became very tired. Hunculu said, "I'll dig for you," and she dug half a *chagra* and could not continue. "When will we ever finish?" she asked. "I can't work anymore!"

But then she regained her strength and attacked the soil with her digging stick, going deeper into the unproductive base of the forest, rather than remaining in the litter and rich upper soil. Whack, whack—a great hole was made. Down went Hunculu into this hole, down into the base of the forest roots, digging and digging.

Nungwi looked down into the hole at her daughter and blew on her with her magical breath, saying, "Stay that way," and she turned Hunculu into a large frog. And so Hunculu remained, and so she is today, a sentient, feminine being deep within the roots of the *chagra* and forest. Hunculu then looked up at Nungwi and said, "*Suuuuuuuu* Nungwi mama, *saquiringui*." And Nungwi stayed as she is today, a harmless white-throated black coral snake with a mouth too small to bite even the little finger of a human. Nungwi now

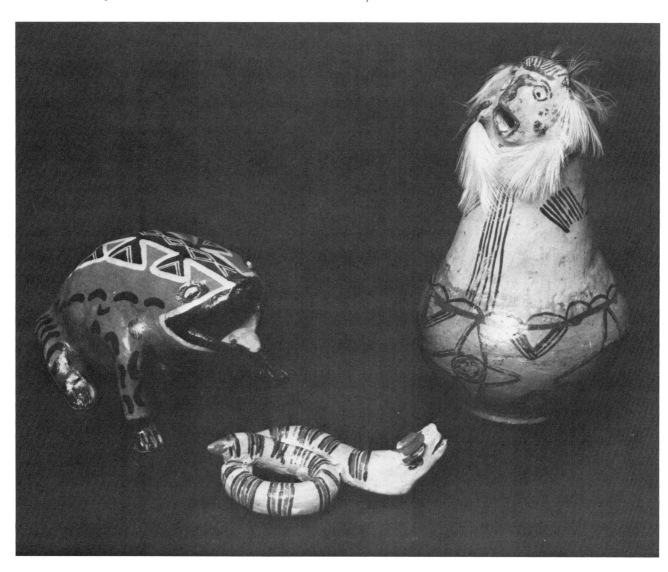

appears to Runa women as a beautiful spirit woman dressed in shimmering blue-black, and she leaves special red or black garden soul stones for human women to find. The stones help them develop their agricultural knowledge. Nungwi then blew on Quindi and created him as he is today, as the hummingbird.

Thus began the manioc garden, from which comes the fundamental food energy of Amazonian peoples, their source of life-sustaining *aswa*. Nungwi remained in the leaf litter as "upper Nungwi" and in the soil as "lower Nungwi," where she could control the growth of roots, pushing up the precious stems and being sure that the soul substance "within" was imbued with her totally feminine power of fecundity. Hunculu stayed "within," too, in deep holes in the *chagra* and in the forest, a domesticated female link to the encompassing rain forest. Quindi, too, remained on the *chagra*, where his presence constitutes the only male force in this domain of feminine domestication.

Quilla and Hilucu

Hilucu, a beautiful woman whose avian manifestation became the Common Potoo bird, had a handsome lover who came to her house only at night. After becoming pregnant she wanted to see the father of her child so she cooked a *widuj* seed from the *Genipa americana* tree. That night she painted her lover's face and body with beautiful designs, telling him that it would make him feel fresh (*Genipa americana* is an astringent). Much later, in the predawn hours after he had left, she looked at the sky and saw her brother Quilla, the moon. His face and body were covered with black designs, exactly as she had painted her lover.

She knew then that she had committed incest, that her children would inherit male and female soul substances from the same consanguine source. Her sisters, including Manduru warmi (red woman) and Widuj warmi (black woman) also "saw" that the moon and his sister had enjoyed an incestuous union. They, too, painted their faces black with *widuj*, and as they cried their tears fell to earth and seeded the black *Genipa americana* tree in all of the areas where the contemporary people now live and where their ancestors lived. All the stars cried too, producing the dreaded merger of rain, earthquake, and flood. The rivers swelled, volcanos erupted, new high hills appeared, and the earth shook and shuddered.

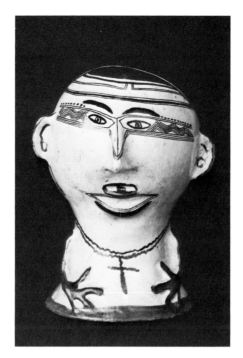

Quilla
Dina Hualinga

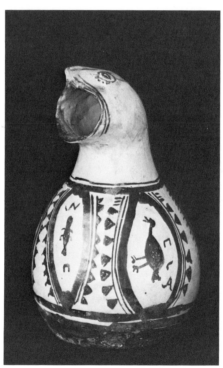

Hilucu
Erlinda Manjia

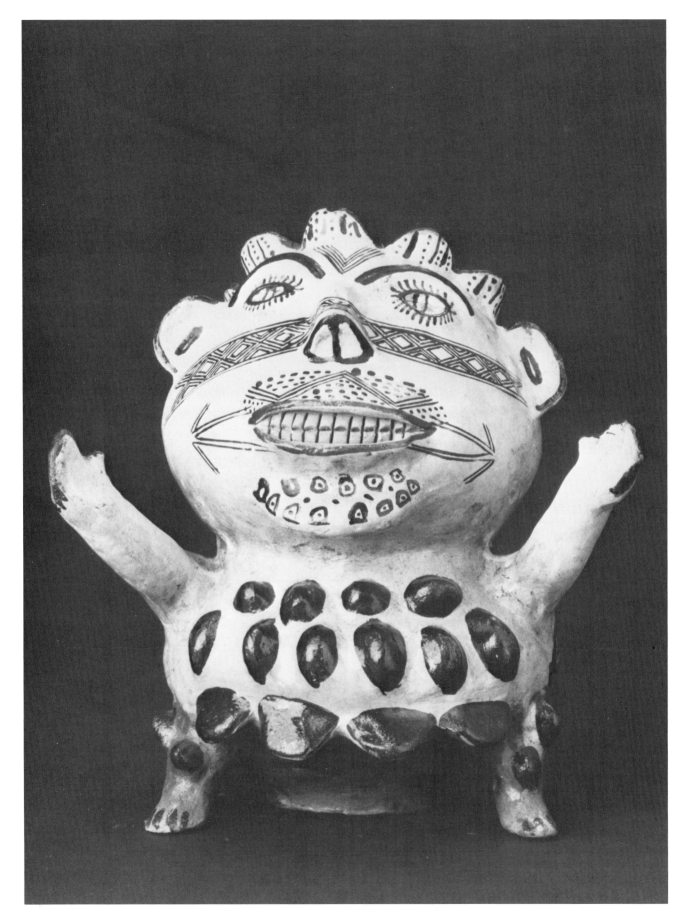

Cachi amu
Esthela Dagua

Origin of the Sun, Salt, and Seed Beads

With this collective crying the earth people were caught up in a great river which swept them eastward into the (Amazonian) sea. Out of this river came Indi, the sun, who had previously been in a cave at the base of the Andes. He ascended to the sky to begin his regular course and to bring an orderly east-west axis to the earth world. As Indi exploded out of the Amazon, thousands of tiny colored bubbles flew outward, as did thousands of white ones. The colored bubbles became seed beads, to be found later by deep Amazonian peoples such as the Achuar Jivaroans and Cocama Tupians, who traded them westward to the Canelos.

The white bubbles became salt that lodged in eastern mines to which the Runa would trek for this desirable flavoring for their native foods. Some Runa would travel for a year or more to the Marañón River area where, many say, they had to appease not only Jivaroan, Cocama, Candoan, and other residents but also the Cachi amu. Cachi amu is an undulating overseer of salt, which is often regarded as sentient by the Runa. Many women, especially master potters, say that Cachi amu is strictly feminine, but men, whose fathers made the trips to collect salt, say that Cachi amu is androgynous.

It is said that, on the way to mine Marañón salt, a mythical older brother and younger brother had an adventure. They were stranded in a bird's nest high in the canopy, having been deposited there by the nest's builder, a huge man-eating hawk. After killing the wife and children of the hawk, they called for help and a caterpillar associated with the manioc garden came to them. First she carried the older brother down, telling him to keep his eyes tightly shut. Then she did the same with the younger brother, but as often happens in the myths of these two brothers, the younger one disobeyed her and opened his eyes. The caterpillar fell off the tree, breaking her back, while the younger brother fell into the turgid water and was swept away.

Following the explosion of the sun out of the Amazon, and the creation of seed beads and salt, night and day developed. The moon and stars lost some of their power due to the incestuous relationship between Quilla and Hilucu. Night was to be dark and a domain of chaos dominated by the moon; day was to be light, warm, and the font of order dominated totally by the sun.

Soul Restoration and the Resurrection of Man from a Bracket Fungus

During the flood, caused by the collective crying of the stars, Runa were swept eastward into the Amazon River sea and became separated from one another on many occasions. Each time they had to wander westward, often alone, looking for people like themselves. During their return, wandering Runa had no manioc to eat, and they had to fight and kill animals with palm sticks. They ate tree mushrooms and lichens, called *ala*, and a species of Araceae called *laglia tupi*. Eventually the Runa found their way back upstream to the hills where their ancestral grandmothers had planted swidden horticultural gardens of manioc. They recognized the *chagra*s by the *huayusa* (*Ilex* species) trees that had been planted by their special shamanic ancestors. During this trip many of the mythic or legendary ancestors of the contemporary Runa shared the following experience.

Two brothers were deposited by a condor on a great rock in the middle of a mighty river. The older brother called to a caiman, "Come Apamama [grandmother], take us across." "Go first, younger brother," the older one said. But the younger one, always contradictory, said, "No, you go first, older brother." So the older brother did. "Close your eyes," said caiman-Apamama, and the older brother kept his eyes closed all the way and arrived safely on the bank of the river. But true to form, on the next trip the younger brother did not keep his eyes closed. Apamama snapped off his leg and he fell into the water and was swept away.

The older brother eventually found the younger brother, who was being kept by the caiman in its underbank den of a stream. The older brother then threw termites into the water, drying the entire stream; other caimans came and identified the culprit caiman to the older brother, who took the missing leg, with its human soul, and put it back on the younger brother, who promptly disappeared again in a series of chaotic adventures.

The older brother once again searched and searched for the younger one. Eventually, heading upriver and very hungry, the older one spied a bracket fungus growing out of the huge trunk of the mindal tree. "The ancients ate mushrooms and lichens," he thought to himself. "I wonder if this is edible; I think I'll take a bite." He started to break off a bit of the bracket fungus, called *ala*, and it

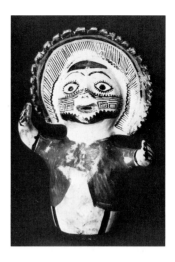

Indi
Santa Hualinga

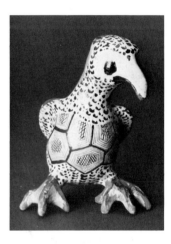

Baby hawk
the late Pastora Watatuca

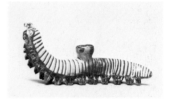

Caterpillar coming up a tree to rescue a stranded youth
Esthela Dagua

47

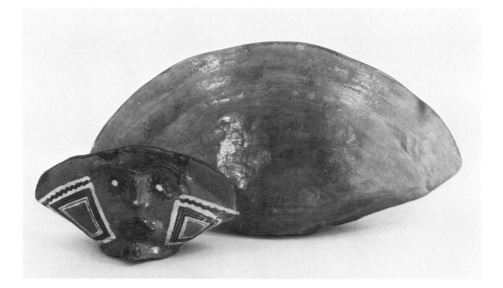

Bracket fungus transforming
into a lost brother
Esthela Dagua

cried out, "Ouch! Don't pinch me brother, that hurts!" And the bracket fungus turned into the lost younger brother.

Origin of Beauty, Power, and Liberation

Two women, Manduru warmi (red woman) and Widuj warmi (black woman), were walking in the forest and they came to the house of a foreign monkey-person, Machin runa. While they slept in the center of his oval house, Machin tied them up with palm fiber, and when they awoke at dawn they found that the fiber had grown into spiny bamboo. They were trapped in a cage of long, sharp thorns that could impale them if they were to struggle against it. They cried out, "Who can help us?" Hearing their cries, the game birds of the forest arrived one by one, each as a warrior. First came Paushi (currasow), but he could not help; he did not have the capacity to cut the bonds, and he dulled his beak trying. Then came Pawa (guan), and the same thing happened. Munditi (hoatzin) tried, then Yami (trumpter), then Carunzi (chachalaca) — still failure, still inability to accomplish the task of freeing the women, even though all of these birds were warriors.

Sicuanga runa arrived next with his great machete, and he cut and slashed the bamboo and freed the two women. They then blew their magical breath on him, each saying "Suuuuuu Sicuanga runa; stay this way." Widuj painted him black with genipa, then Manduru painted his beak, collar, and the top of his tail with red and yellow. Together they gave him white, fluffy cotton for his breast. He became, and he stayed, Sicuanga; he flew and became the toucan. The two women then changed other birds into their present, diverse avian forms, and they made game animals and game birds for

humans to eat. Then they blew on Machin and made him into a monkey, almost human, and he too stayed that way. Then the two women said, "What will we be?" One said, "I'll be Manduru" (*Bixa orellana*), and the other said, "I'll be Widuj" (*Genipa americana*), and they became the two trees whose seeds provide red and black dyes to the Runa.

Mythic Imagery and Contemporary Creativity

Festival effigy vessels brought forth by women during periodic ceremonies are quite literally packed with the symbolic imagery of external domination and internal power. We offer here one of hundreds of examples of the way a pot itself can serve as a vehicle to convey meaning to those who are part of this culture.

In 1973, oilmen were coming and going on the Curaray River in motorized canoes, signaling the possibility of what native people think of as "times of secular chaos." Alegría Canelos, a master potter, constructed an interesting and, at first glance, whimsical effigy pot for an Easter festival held in the Josephine Mission-controlled plaza. To anyone who knows Canelos Quichua imagery, the pot represents two utterly distinct but inextricably conjoined worlds — the secular, international political economy of escalating domination in all parts of Ecuador, and the sacred, indigenous way

of life based upon the relationships among spirit masters of the hydrosphere, rain forest, and garden soil and pottery clay. Looking first at the upper segment of the pot one sees an oil boss riding in a motor-driven canoe, holding onto his hat and shouting strange orders to native workers — once a common sight on the Curaray. The oil boss represents, in corporeal form, the *machin runa*, a monkey-person. In spirit form he is the forest master of other people, other people's Amasanga, the fearsome Hurihuri spirit that coughs like a jaguar.

Alegría Canelos decorated this monkey-like spirit person from the world of political-economic domination with anaconda spots, with head and neck rearing out of the water. When a human being swims under the water and encounters an anaconda, enormous danger exists. When the person surfaces the anaconda surfaces with him, and the instant the human head is above water the anaconda strikes. This is what all the Canelos Quichua say, and this is what Jacques Cousteau's cameraman learned when videotaping an anaconda sequence for the four-hour television documentary *The Amazon.*

Looking at the bottom of the pot we see that the monkey-man in the canoe rests on a turtle seat of power, with anaconda spots

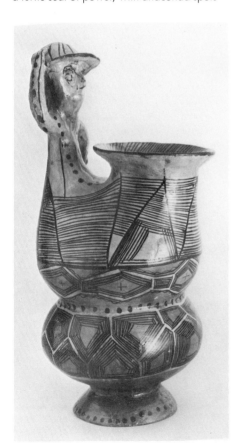

on the base. The turtle is *charapa*, Amazonian water turtle. As a reptile, its eggs are an important source of food for humans. As spirit force, the *charapa* is the seat of power of Sungui, the first shaman and the ultimate source of shamanic power. Sungui himself appears to human shamans as the anaconda; to some humans as a naked, bearded white man standing on a riverbank; to vision seekers and dreamers as a shimmering spirit person (usually female) dressed in rainbow colors; and to all as a rainbow, or double rainbow, in the hydrosphere that contains all of the earth. Looking more closely at the canoe motif, we see that it, too, is adorned with the anaconda design and that this design encapsulates Christian cross symbols. Such graphic encapsulation evokes knowledge of the historical process of containment and replication of the dominant political economy which itself reproduces antimony and orders chaotic relationships.

Women and men sing highly evocative songs during such ceremonies. Clara Santi Simbaña, a master potter, sang one about the toucan at a particularly chaotic festival event in 1982. She, with her brothers and sisters, had worked hard with the regional governmental officials, and with their opponents, to influence them to construct a road to her hamlet on the edge of a large, dispersed residential area. Clara had also worked with the same people to preserve fine pottery housed in a "forest museum." Dissent reigned at the museum site; some wanted to maintain the museum, while others wanted to cast it aside in favor of new commercial activities that would increase participation in the modern economy. As Clara watched the conflict develop, two bulldozers, a road scraper, and seven dump trucks arrived to demolish the museum, level the entire area around it, and cut another swath of the new roadbed. As the heavy machines droned outside her home, Clara sang this song:

> Yao sicuanga warmi mani
> Yao sicuanga warmi mani
> Hatun urcu pundaybi, shayarishamilla.
> Shiwa muyuta, caiman tili tili micusha
> Shiwa ruyabilla tiyarisha muytalla micusha
> Purinilla purini
> Yao sicuanga warmiga
> Shuj muyullata wicsapajtalla micusha, purini,
> indi ñawita ricusha.
> Caiman wiwiwin; chiman wiwiwin,
> Caru chulla cai Yao sicuanga warmiga
> Mana wanchilla micupi casna,
> casnalla cantashalla purinlla.
> Yao sicuanga warmiga
> Paiba aichatalla mana micunguichu
> cantanyari cantanyari.

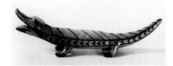

Caiman
Martha Vargas

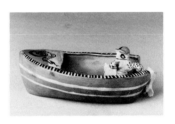

Another rendition of foreign intrusion at Curaray
Inez Padilla

Oil boss riding in a canoe, holding onto his cap, and shouting orders
Alegría Canelos

Widuj warmi and Manduru
warmi
Erlinda Manjia

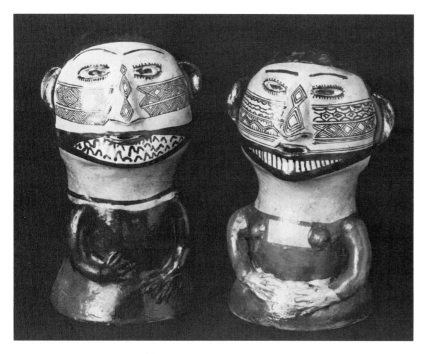

I'm toucan woman, I'm toucan,
Yao sicuanga woman;
just standing on the big hilltop,
eating palm nuts there. Sitting in the palm tree,
eating only nuts, I walk, just walk.
Toucan woman, eating another nut for her belly,
I walk, looking at the sunbeams.
Distant and alone,
this toucan woman doesn't kill in eating this way.
She's just walking, just singing this way.
Toucan woman,
"Don't eat her flesh,"
it seems she sings, it seems she sings.

By singing as the *yao sicuanga*, a species of toucan, Clara brought the mythic imagery of liberation to a traumatic and chaotic modern event. By saying that she was "standing," she meant that she was "ready" to confront chaos, to find a way to liberate herself and her people by means of more evocations of inner power. She brought forth the imagery of the sun to indicate that order is being created. When men or women are far away, it is said, and the sun's rays warm them, they are like a toucan high in the tree, luxuriating in the sun, nearly melting from its warmth, and always waiting, always ready to move quickly and decisively, to return home, to liberate. By talking of eating nuts, Clara

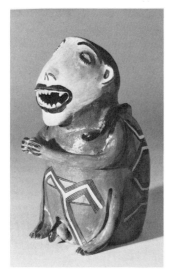

Machin runa
Esthela Dagua

evoked the image of people feeding off nature but not destroying nature; by saying, "Don't eat her flesh," she symbolized the devouring character of the external political economy, which contrasts sharply to the indigenous system of ecosystem maintenance.

Men working in the ethnic-arts industry are in constant face-to-face interaction with the representatives of the national and international economy, those who buy their creations, and those who usually try to dictate the demands of the market to the creators. Thinking of the song that Clara Santi Simbaña sang, her nephew, Segundo Vargas, and his next-door neighbor, Fidel Watatuca, set about making an array of balsa toucans and monkeys. As they worked with their balsa carvings, their wives, both fine potters, commented on the myth of the two beautiful women (red woman and black woman) tied up by a foreign monkey-person and how the toucan, Sicuanga runa, liberated them and how they and he mutually created beauty and power in one another. A road had recently been cut through their hamlet and dispersed territory, as well, at the request of the native peoples, and the usual combination of advantages of the modern economy and disadvantages of jeopardy for native Amazonian society was obvious to all.

As the men worked, some of the women began carving as well, making uproarious jokes about monkeys and toucans and jesting about sections of mythology, drawing from it to create new metaphors from domains of *unai* (Mythic Time-Space) and *cunalla* (right now). They talked of prices, how many Ecuadorian *sucres* their toucans and monkeys would bring, and what they would do with the money. They were pleased when they discussed their economic independence and how they no longer needed to fear the debts that accompany bank loans, but they became sad as they admitted to one another that time was no longer their own to control. Segundo said that *hatun wicsa* Jorge (big belly George), a prosperous exporter and middleman in ethnic arts who lived in nearby Shell, a town constructed by Shell Petroleum Company in 1937, had placed an order for 1,000 toucans, exactly 28 cm high, with a girth of 12 cm, and he showed us the tape measure he had been given. "It's like being in a cage," his wife said, sitting down to paint small ceramic bowls to sell in Puyo. "But with the money we can buy our way back out," said Segundo.

Then they talked of *caya*, the future, and wondered where they would come to fit into a disappearing frontier. Beauty kept flowing out; money was coming in. The foreigners were all around; some of them were interested in indigenous knowledge, vision, and perspective, but most were not.

Then Clara, listening to the others talk, softly but assertively sang this song:
Big monkey [stranger], big monkey,
from just here he will call.
They say that if the big stranger comes,
he will stay, dying in a great big trap; he will stay.
The big, big monkey-like person is just coming,
he just stays, remains, dead.
What are you saying to me, little sister;
what do you say to me?
Perhaps he didn't die,
perhaps he will come — we shall see, little sister.
Perhaps the monkey-person isn't dead.
My dear husband, my dear husband;
he was outside, perhaps in vain; he became dead.
He will come, little sister, we shall see, little sister.
We shall see his face, little sister.
Little sister, little sister, listen to what I am saying.

The big stranger (monkey) represents the huge North American petroleum engineers for whom the Runa have worked from time to time. Lacking a full soul, they are regarded as partly dead. Clara's husband, Abraham Chango, went out to work for a petroleum company; by so doing he entered the domain of the part-monkey, part-dead. He worked for money, all of his labor sold so that his household could purchase necessary goods. Now with the new road the outsider comes to bring death to us all. But humans, at times, pass over thresholds through the portals of death and come back out again to the living, becoming transformed in the process to more knowledgeable people, knowing more of what is outside, if they survive.

"*Suuuuuuu* Sicuanga, stay
this way"
Toucan: Alicia Canelos; woman:
Santa Hualinga

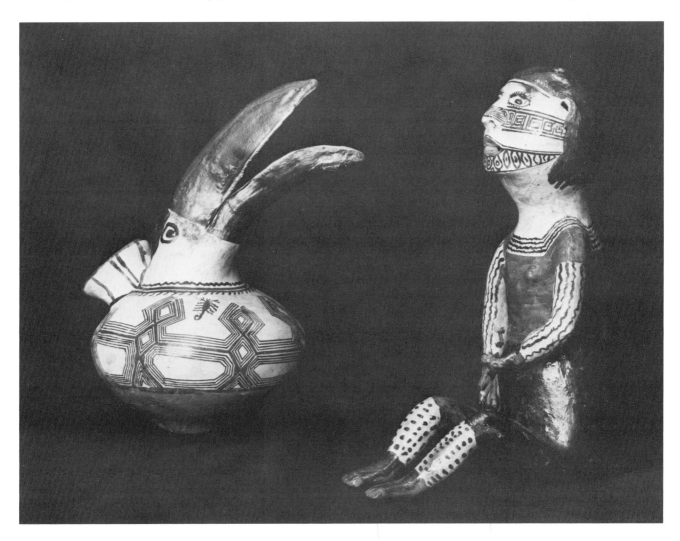

Profiles of Some Artists

Marcelo Santi Simbaña and Faviola Vargas Aranda

Marcelo Santi, age fifty-four, was born in Puyo. He and one brother attended school there for two years in the early 1940s before his father, the late Virgilio Santi, sold his land to a foreign immigrant and, under pressure of Andean colonization, moved southeast of Puyo. There Virgilio and several brothers fanned out and laid claim to hundreds of hectares of forest-riverine territory, each brother, together with brothers-in-law, founding a specific settlement. By 1947 a formal territory — the Comuna San Jacinto del Pindo — had been officially declared indigenous domain by presidential decree, the first such native land to be granted in Amazonian Ecuador. Marcelo married Corina Vargas, whose Achuar parents had migrated westward from Peru and joined the Canelos Quichua on the comuna and adjacent territory in their defense of land against Andean colonization. They lived in a very rugged forest area not far from the Pastaza River. Corina died in childbirth with their fourth child.

To earn hard cash to support his family, Marcelo allowed himself to be lured into a position of debt peonage (*enganche*) by a labor recruiter in Puyo. In 1958 he went off to work in the coastal region of Santo Domingo de los Colorados, leaving his children with brothers and sisters in a dispersed settlement near the northern edge of the comuna. He left plantation labor before becoming dependent on it and traveled back to the eastern rain forests, where he resided in Canelos between 1960 and 1967. There he married Faviola Vargas Aranda, with whom he had seven children. Faviola, now age forty-five, was born and reared in Canelos, where most of her relatives still live. Marcelo and Faviola made their home near the Villano River, at the northwestern edge of Canelos territory. Virgilio, with other native people from Canelos, had once cleared a wide swath through the forest all the way from Puyo to Curaray, including Marcelo's and Faviola's Villano site, for what was to have been an Ambato-Amazonian railroad. While there they heard many stories about such clearing and about the days of the Amazon rubber boom and its ravaging effects. They remember their home deep in the forest with great nostalgia.

While living in Canelos, Marcelo delivered mail for the regional system of administration. He carried mail from Puyo to Canelos and on to Pacayacu and Sarayacu on the Bobonaza River. This he did by canoe and by trekking, sometimes taking different routes to learn even more of his social and natural environment. Occasionally, he would also trek to the Copataza River far to the south, in Achuar territory, to visit relatives of his (through Virgilio), Faviola's, and the late Corina's.

In 1967 Marcelo and Faviola returned to the Comuna San Jacinto to participate in the nucleation of a section of the comuna and to join the growing hamlet of Río Chico. They were given a generous portion of Virgilio Santi's land, established a *chagra*, helped to clear a plaza on top of a hill overlooking the rain forest to the east and snow-capped Andean peaks to the west, and built a home on the south edge of that plaza. Marcelo often trekked to the site where he had lived with Corina and still maintains close friendships, bolstered by kinship and ritual co-parent ties with the various people living there. In the late 1970s three of his adult sons, with their spouses and children, moved to that area to establish residences and gardens and to live an essentially subsistence life. In 1982 Marcelo and Faviola began a *chagra* there, as well, near the site where Marcelo and Corina had lived some thirty years before. Shortly thereafter Marcelo, Faviola, and their sons, daughters, and in-laws founded a new hamlet, giving it the name Campo Alegre.

By this time, manifestations of growth and development in Puyo were ubiquitous, and the political-economic and administrative situations were such that a twenty-mile-long road was cut right through the site of what became Campo Alegre. By 1984 Campo Alegre had the largest school in this sector of indigenous territory, a complete plaza, and its residents were traveling from Puyo to Quito in search of authorizations and funds to build an electric plant and to acquire other accoutrements of modernization. In the midst of such transformation, Marcelo became a traditional shaman. Many of his clients came from the Andean region of Otavalo, and eventually he traveled there too, to share and exchange knowledge of control of power with other healers of his level of development.

Marcelo is a master woodworker who properly regards his utilitarian crafts to be art. In addition to making most things needed for his household, forest, and garden activities, except blowguns, he has made

superb wooden traditional objects that have been exhibited as part of the permanent collection of the Museum of the Central Bank of Ecuador, in Quito. These include a canoe, a huge bowl for pounding manioc, and a stool (seat of power).

Faviola is a traditional potter who now works only with polychrome ceramics, which she makes almost exclusively for her own household. She has made a number of whimsical effigy jars that have been featured in various publications, and she has made drinking bowls and storage jars that are in the collection of the museum.

Clara Santi Simbaña and Abraham Chango

Clara Santi, fifty-eight, is Marcelo's sister. At the age of fifteen she married Abraham Chango, now sixty, who came to Puyo with her father, Virgilio Santi, not long before the tumultuous World War II years, when indigenous territory was punctuated by foreigners on opposite sides of this global conflict and where a bomb was actually dropped from a one-engine Peruvian plane only a hundred yards from where Virgilio was clearing forest for a *chagra*. From an early residence in San Jacinto, Clara and Abraham moved downriver on the Pindo to the recently founded hamlet of Rosario Yacu, establishing swidden gardens within a couple of hours' hard trek from the hamlet, one of them at Curi Minas Yacu, the other near Ishcai Tucushca Chingosimi. As their family grew (they now have ten children of their own, have lost three others, and are rearing two daughters of one of their deceased daughters), their adult sons and daughters married and fanned out, and Clara and Abraham also moved to join the establishment and development of Río Chico, keeping their swidden gardens within their original dispersed territory. They also continued to play pivotal roles in the annual festival held in Rosario Yacu, while engaging in modern politicking in Río Chico.

Abraham himself has a number of relatives in the Achuar territories of the Capahuari and Copataza river regions and has often traveled there, with Clara and children, to visit them; they also come from time to time to visit him. During such treks Clara and Abraham take clothes, thread, powder, shot, fishline, and fishhooks with them, and they return with turtle eggs, roasted and

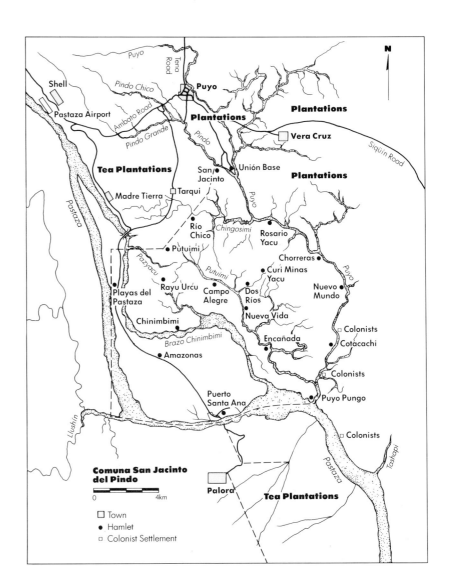

Comuna San Jacinto del Pindo

Apacha Vargas, on her way to see her ceramics displayed in an exhibition in Quito

Above, Clara Santi Simbaña (seated on right) with daughters and other relatives

Juana Catalina Chango sculpting eyes on her ceramic tapir

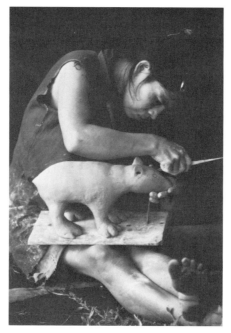

are deeply imbued with a massive repertoire of mythology and just as deeply imbued with observations of life around her. Once, when someone very close to her was in deep trouble, having defaulted on a bank loan, she incorporated this situation into an intricate design on a small *mucawa*. First she made a zigzag and explained that this represented the bends in a river through which her friend, Challua (his nickname, which is also the name of a common fish in the region), was traveling. Next she filled in the zigzag to create hills, where Challua would stop and visit relatives who now spoke Quichua but whose forebears spoke Záparo (a language that her mother, too, knew well). Then she put dots on the points of the triangles where the zigzag lines met. All watching knew that she could be representing either the strings that hold the heads on a drum, or a fishnet, or both. She just looked around the room and sighed, and everyone knew at once what she had done — she had represented the drum of Challua, who enjoyed so much the power of the traditional festivals, and the very bank loan (as a fishnet to catch him) that currently ensnared his modern life.

Abraham, now one of the true elders of the area (as is Clara), is also an image maker. There is no element of the tropical forest with which he is not familiar, from chambira fibers to bark cloth, from resins and seeds to hard and soft woods. Both he and Clara have samples of their works deposited in the Museum of the Central Bank of Ecuador, and buyers of ethnic art from Quito, Guayaquil, and elsewhere often come to their home in Río Chico to purchase ceramics and wood. Tradition abounds in their household, as does modernity. One of their sons is a member of a crack paratrooper division of the national infantry, currently housed south of Quito near Machachi, and a daughter works for a radio station in the Andean city of Latacunga.

Another daughter, Juana Catalina Chango, plumbs the depths of her cultural knowledge to produce evocative ceramics and songs. She has been particularly concerned about portraying rain-forest animals threatened by extinction or on the verge of extinction, and she has devised her own technique of combined coiling and sculpting to make, for example, an oversized mother tapir and its spotted calf. Juana originally learned a repertoire of songs from her mother, grandmothers, and other older female relatives, and she frequently reinterprets these in the context of her personal experiences. Song, for Juana, is a vehicle by which she sends messages to distant loved

smoked meat and fish, blowguns, feathered headpieces, and other forest and riverine products.

Clara is an indefatigable creator, sometimes referred to as a *sinchi muscuj warmi*, strong image-making woman, by her family and friends. Although Abraham is not a shaman per se, Clara is certainly the female ceramist analogue of a powerful shaman, as befits her position of eldest daughter of a *sinchi yachaj* (Virgilio Santi). Her creations

ones through the medium of ancient spirits. Spirit beings such as Amasanga and Amasanga warmi are not only described in Juana's song-poems, but she also recreates them in ceramics. She has explicitly stated her desire to communicate her ecological and spiritual knowledge to people in the United States and other nations.

Alfonso Chango and Luzmila Salazar

Alfonso Chango, thirty-one, the son of Abraham and Clara, is currently the president of the Comuna San Jacinto del Pindo, a 17,000-hectare indigenous territory. This territory, the first region to be granted to indigenous people in the Amazonian region of Ecuador, has a current population of approximately 2,000. Luzmila Salazar, twenty-eight, is the daughter of a powerful shaman who has long healed nationals and indigenous people alike from his house in a mixed colony of migrants and native peoples on the Napo Road, just north of Puyo.

Both Luzmila and Alfonso engage constantly in activities attendant on life in a hectic, OPEC nation-state. Each enjoys cradle bilingualism in Spanish and Quichua, and each has considerable exposure to various levels of Ecuadorian society in Amazonia and the Andes. After some work for petroleum exploration companies, Alfonso entered a program to train Episcopalian brothers, and he took courses in Quito and near the town of Tarqui, on the edge of the Comuna San Jacinto del Pindo. From there he went to the Napo River region, where he worked on a plantation for two years, earning sufficient money to complete a one-year course to become a professional light-vehicle driver and to purchase a well-worn, barely serviceable Land Rover.

Alfonso and Luzmila are both fascinated with the mythology and legendary knowledge and insights of their respective parents, and they seek to express these in a new medium. Toward this end, working together, they have become artists and narrators. Alfonso, with the help of Luzmila, draws pictures that depict the strong and sentient images created by Clara, Abraham, and Luzmila's father, Domingo. Then they both provide narration, in Spanish and in Quichua. When sufficient drawings and

descriptions have been assembled, they collate them into meaningful themes that express important facets of indigenous cosmography. One result of this work is a small book, with color illustrations, entitled *Yachaj Sami Yachachina* (Shaman's Class Teachings). They have now developed sufficient material for several more books, the next one to be *Muscuj Warmi Awashka* (Image Woman's Work).

Delicia Dagua and Rubén Santi

Delicia and Rubén, both thirty-one, have combined a hard life deep in the forest with equally hard work in modern sectors of Ecuador. Rubén, son of Marcelo and Corina, left early for *enganche* labor for a foreign petroleum company in the area of Villano and Curaray, where he resided for a time in base camps and forest outposts in the very location where Marcelo and Faviola once had their swidden garden. He remembers well a time when the scheduled helicopters did not arrive to ferry him twenty miles away, where he had been ordered to lay more dynamite wire. Together with a young uncle, married to Luzmila's sister, he trekked for fourteen hours to the site, through hostile Waorani indigenous territory unknown to him, carrying 140 pounds of wire on his back, with other tools and clothes in his arms.

Delicia was born in the rain forest somewhere north of the Bufeo River, which empties into the Bobonaza River near the

Balvina Santi lacquers a drinking bowl with *shinquillu*, a tree resin

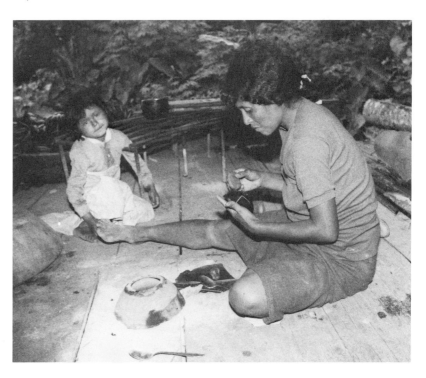

Mucawa
Delicia Dagua

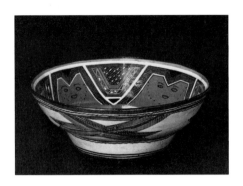

Mucawa
Amadora Aranda

Mucawa

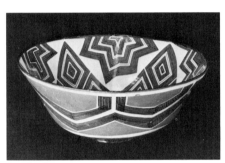

border of Peru. Most of her family is Achuar, some bilingual in Spanish and/or Quichua. Her kin are spread from deep Amazonian Peru all the way to Puyo and Shell, with a prominent relative in almost every indigenous territory in between. At the age of twelve she worked for two years in Quito, as a servant, before moving back to the region around Montalvo. She has traveled throughout the Bobonaza River region, trekking when she was only seventeen to what today is Llanchana Cocha, visiting there with Zaparoan-speaking peoples at a time when they would hide the fact of their Záparo-Quichua bilingualism from those not thoroughly trusted. In 1976 she came to Puyo to work; there she met Rubén and they eloped, residing initially in Río Chico.

Within a year or so of their marriage it was clear that Río Chico was becoming crowded. There was plenty of hamlet space, but adjacent rain-forest areas for swidden cultivation were becoming marbled with small cattle pastures. In 1978 Delicia and Rubén, an older daughter of Delicia, and their own two children moved to what was called the "second line" of Río Chico, the territory described earlier where Marcelo once lived with Corina. Their move was "too soon," for they had not yet finished clearing and planting a *chagra*, and it takes a year or more after clearing before a stable food supply is readily available. Delicia and Rubén lived through several years of real hardship, and Rubén took on various peonage jobs for colonists to earn money for their household. Eventually, the manioc garden and a plantain one were bearing well. Rubén engaged in two additional years of sustained work for a foreign petroleum company on the coast, returning home with sufficient income to buy zinc for a roof, a chain saw, a sewing machine, and other necessities in contemporary life. By this time the road had reached Campo Alegre and Delicia and Rubén relocated, building a large house right across from the main plaza.

Delicia's forte is exquisite design, richly imbued with imagery from the domain of water and from the secrets of *chagra* spirit life. She conjoins such imagery imparted to ceramics with one of the richest stores of lore and observation of the vast rain-forest territory that we have witnessed in a young woman. She is completely at home in garden, riverine, and rain-forest life, and she is equally at home in urban areas. At this point in her life Delicia has relatively little time for sustained pottery manufacture, but as her children grow and take a burden of full-time swidden work from her, the arrays of lovely decorated ceramics should again emerge.

Rubén, like his father, works in wood, and he is especially adept at making fine drums and seats of power. But time for such crafts is no longer his to enjoy, for he is working in the forest day in and day out to provide wood to fulfill the cravings of an expanding lumber market. He must have hundreds of sawed logs ready at roadside at a previously designated time for the trucks from Quito, Ambato, and Puyo, and he must spend considerable energy and money in Puyo itself hunting for the buyers and hounding them to get the money he has earned from them. Those who purchase lumber and logs are slow to pay, but Rubén, and so many others like him, must pay hard cash for everything purchased, including a second chain

saw, spare parts, gasoline, and oil. The struggle to remain outside of debt peonage is a harsh fact of everyday existence.

Segundo Vargas and Balvina Santi

Segundo and Balvina, both thirty-two, eloped in 1971; by 1972 their families had consented to their marriage. Balvina is a daughter of Camilo Santi Simbaña, oldest brother of Marcelo and Clara and one of the founders of Rosario Yacu; he married Soledad Vargas, who died in 1985. Soledad's parents, who carried the indigenous Achuar names Nayapi and Mamach, were founders of the territory of Rosario Yacu. Segundo is one of many adult children of Baltazar Vargas and Theresa Dagua, who are the children of the founders of Chinimbimi, on the opposite side of the comuna from Rosario Yacu. Segundo was born and reared in the southern-most sector of the Comuna San Jacinto, not far from the territory where Marcelo and Corina once lived. Today Segundo, Balvina, and their seven children live by the road that cuts south through the comuna, in the hamlet of Nueva Vida, which means "new life."

Soledad was a master potter, a woman who knew how to make the entire gamut of blackware forms, something not found commonly today. Balvina learned her mother's skills but prefers to create delicately painted, small *mucawa*s, the size used for serving an especially strong drink *(vinillu)* during annual festivals or, occasionally, for a datura quest. These are favored on the ethnic-arts market because of their size and beauty. Segundo is the person who began the ethnic-arts carvings. In June 1975 he saw two examples of tourist art—wood carvings made by the Chachi native people of Esmeraldas Province of coastal rain-forest Ecuador. Within two weeks he carved an agouti and a caiman. As a surprise, when Segundo brought these to us in Puyo, Balvina came ahead of him, holding a fine, handmade rope tightly, as though controlling something alive and wriggling; behind her came Segundo, holding the wooden caiman as though it could escape.

Other Puyo Runa men who saw Segundo's work began to experiment with

wood carvings. Soon a variety of birds and animals were being made, some from hardwoods but most from balsa. Since this time Segundo has been one of the leaders in continuous innovation. He has, among other things, carved toucans with detachable beaks and parrots and other birds with detachable wings. Today Balvina and Segundo work together in their house in Nueva Vida; she not only works with her ceramics but also carves wood.

Apacha Vargas

One of the most powerful men of what is now Pastaza Province was Acevedo Vargas, later called Severo Vargas. Known everywhere as *sinchi curaga*, a strong leader, Severo derived his regional authority from the Dominican priests of Puyo and Canelos. He also enjoyed the *curaga* title because he would, when necessary, rally people against the church. He was a legendary and historical power broker between church-state centralized authority and dispersed indigenous dissidence. His knowledge included language facility in Achuar Jivaroan, Andoas Jivaroan, and perhaps in Shimigae (Andoas) Zaparoan. It is said that José María Velasco Ibarra, the great and controversial president of Ecuador, who served five times but never completed a term of office, would travel to the current site of Unión Base where Severo would cure him of mystical illnesses caused by Andean witchcraft by sucking magical darts from his body.

Severo's oldest daughter, Denise Curipallo Vargas, who is now fifty and is known by everyone as Apacha, acquired his powers and converted them to the medium of ceramic manufacture. She and her husband, Dario Vargas, also fifty, have long resided on a high hill overlooking the Puyo River near its junction with the Indillama River. This strategic location on the old Canelos trail, not far from Puyupungo, entryway to ancient Chirapa Jivaroan territory, and contemporary Shuar territory to the south, was a nexus of intercultural, intra-indigenous movement.

Apacha, through her father, claims affiliation with the ancient Caninche of what is now the Sigüín mountain range east of Puyo and the Comuna San Jacinto del Pindo. She remembers well not only the varied indigenous cultures whose representatives have intermingled in this zone of the Indillama-Puyo confluence but also the various foreigners who have trekked through her territory, usually employing relatives of hers as guides and bearers. She and Dario also participated

Segundo Vargas studies the catalog of the Quito art exhibition. His father-in-law, Camilo Santi, whistles the shaman song being played in the background.

in hamlet nucleation, working on the plaza and school of Nuevo Mundo (New World) in the early 1970s.

Apacha has traveled widely in the Amazonian forests and also to the cities of Ecuador, especially Quito, where her creations are in particular demand in the finest giftshops of the nation. She is particularly adept at creating a traditional figurine, such as a caiman, and then creating its modern analogue. For example, she created the caiman illustrated on this page.

Soon after, on a Saturday evening, Apacha went to a movie with her husband and three of her ten children. She had been reflecting on the nature of indigenous power and the ways by which external forces could so diminish indigenous existence in the urban areas of Ecuador. She could not read the film's subtitles, nor could she understand the English translation from the Japanese, but she enjoyed watching the film in which people ran around a big city (Tokyo), much as they do in Puyo, and soldiers roared around in jeeps and trucks, strikingly like the presence of an entire military brigade in Puyo's annual founding-day parade. As she watched the

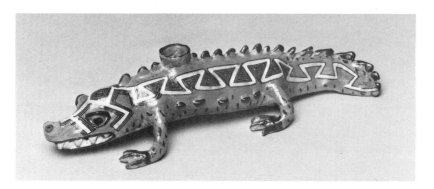

Caiman
Apacha Vargas

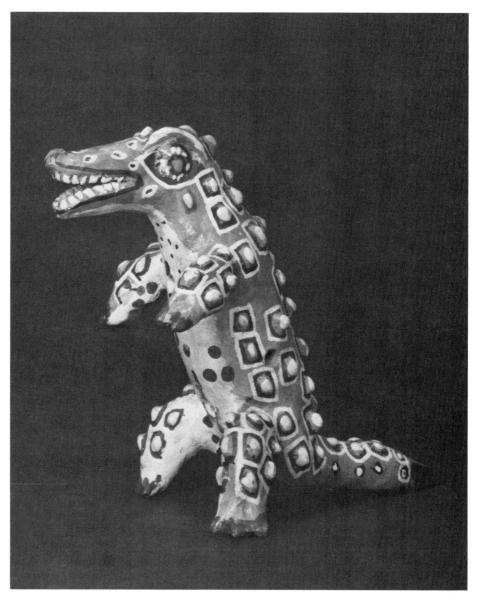

Godzilla
Apacha Vargas

movie, she pictured troops goose-stepping before the reviewing stand in front of the Dominican Mission, and she remembered the sounds of airplanes buzzing the plaza. On the screen she saw a mighty caiman rise out of the Sea of Japan and then stomp on sky-scrapers, causing general havoc. Days later, at home, she created the ceramic image of Godzilla.

Apacha is also one of a minority of women so skilled in natural and supernatural powers that she creates virtually at will imagery of river and forest and of the cosmos. For example, the scorpion and snake of the shamanic section of the exhibition are made by her, as is the fish with attached parasite and the enlarged parasite itself. We have seen other highly skilled women, ceramists all, look at her creations and just sigh, "They have been made by a strong spirit woman." Then they pause and with reverence say her name, adding, "*sinchi supaimanda warmi awashka*" (made by a powerful woman from the spirit world).

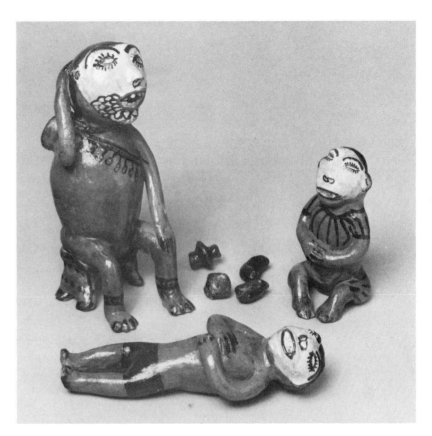

Esthela Dagua

Esthela Dagua, age thirty-seven, was born in Sarayacu. Her recollections of early life are filled with toil and tragedy. With a sick father, she and her mother and brother moved to a swidden-garden region on the Sigüín mountain range to the east, near the headwaters of the Indillama River. They next trekked to Unión Base, on the Comuna San Jacinto del Pindo, to seek advice from powerful ones of this developing region about local curers and also about physicians and shamans of the Andes. Her father died and Esthela and her brother moved to Unión Base around 1970. There she was married to Luis Vargas, who had recently returned from Ambato to reside with his uncle, Severo Vargas (the second), brother of Apacha Vargas. In Unión Base, Esthela began to make ceramics, inspired by Apacha and by other master potters such as Pastora Watatuca. Power abounded in that hamlet, for it was focused on a powerful Zaparoan-Quichua shaman, Eliseo Vargas, who originally hailed from the hinterland north of Sarayacu, near the Rutunu River.

As so often happens to women and men without strong kindred support in a ham-

let, by 1974 Esthela and her husband felt they had to leave Unión Base. Her mother remarried a Shuar from Arapicos and stayed in what was to become the Shuar hamlet of Kunguki, on the Sigüín range. Then the trek began. Esthela and Luis crossed the Sigüín mountains, continued down, then up, and then down again on the hard two-day trek to Canelos. They took what belongings they could on their backs, and Esthela carried one child while pregnant with another. From Canelos they continued on a two-day trek north through exceedingly rugged territory to the Villano region, where she toiled incessantly for two years. In 1976 Esthela took her life and career in her own hands. While Luis went off to work for a petroleum exploration company, she flew in a one-engine plane back to Shell and went to Puyo in search of residence. She was not successful at first and went to live with her mother. In 1980 she found land in Puyo on a tiny corner of a lot owned by a person who had often employed her husband, and it was loaned to her for up to five years in exchange for the free, part-time labor of her husband.

With five children to feed, clothe, and educate, Esthela set out in earnest to make pottery for the ethnic-arts market. Within seven years she became a major producer of fine ceramics in the Puyo area and especially contributed to sales in Puyo itself.

Shaman, his patients, and spirit stones. The shaman is on his seat of power and is regurgitating magical substances from his inner will to help in the forth-coming healing session.
Esthela Dagua

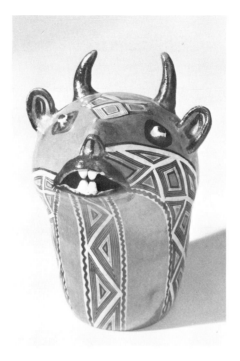

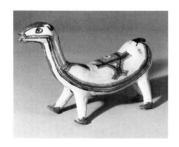

Brocket deer

From restaurants to giftshops and dry-good stores, from little kiosk food stands to new hotels, her whimsical effigy pots were sold, first at low and then moderate prices, as more and more buyers from Quito and Guayaquil sought her pottery. By 1987 her ability to construct an entire array of any complex that came to her mind was absolutely startling. Indeed, the attention her work (and later, she) received locally and internationally prompted considerable jealousy on the part of her landlady, and Esthela was expelled from her household of six years with a scant twenty-four-hour verbal notice.

Esthela, her husband, and their seven children literally camped out in rainy Puyo, first in one room shared with a single woman and then in a zinc lean-to on a probable residence site, until a loan of residential space in return for her husband's free labor was again arranged. Esthela immediately began making pottery in her new setting, and by August 1987 she was forging wares of many styles, from the most traditional blackware to modern whimsical beings, from figurines depicting shamanic procedures to entire arrays of spirits. Esthela's household, cramped though it is in but one room, is something of a hub of indigenous communication. Every week one meets people — Esthela's friends and relatives — visiting from Montalvo, Sarayacu, Canelos, and elsewhere. Recently she traveled to Quito, where she sold her pottery to three of the finest giftshops at good prices.

When we began developing the exhibition held in the Museum of the Central Bank of Ecuador, we found many conceptual gaps and discussed with Esthela the problems we encountered in trying to fill them. She responded quickly and began to make traditional and modern ware to round out the exhibition. Without her we could not have completed it. She saw the exhibition in Quito, with thirty-one other native people, and reflected deeply on the "meaning" of a full exhibition of culture through material art. When we planned the exhibition for Puyo, Esthela again began to help us with vigor. It was for that exhibition that she created some of the pieces in the Krannert Art Museum showing. Later she made the "shamanic curing complex" that complements the section called Control of Power.

It is common in Canelos Quichua culture to say that one is "from" the area one's grandparents claim as their "proper" territory. By such criteria Esthela is from Sarayacu. Because fine pottery is made there, and because Sarayacu is far away from urban life, many, perhaps all, residents of Puyo who care to reflect on beauty and origin accept readily that Esthela, and others like her, learned their skills there or in similar locations. It is incorrect, however, to assume that she learned her skills far from Puyo. Esthela correctly insists that she developed her talents in the town of Puyo itself. She is now *from* Puyo, and women of Sarayacu and elsewhere learn from her, just as they contribute to her continuous growth of skill and knowledge.

For years and years it has been nearly impossible for an indigenous person with a family to reside in Puyo for any length of time, on his or her own terms. Esthela's life there is anything but secure. She dreams of owning her own land in or near Puyo, where she can, with the help of her children, continue to make her ceramics on a full-time basis. She is determined to educate her children to the full extent of their abilities in the schools of Puyo, but during vacations she sends some of them to relatives who live in traditional Canelos Quichua areas. She has become, over the past few years, a "strong vision- and image-making woman," one who is laboring to reap sufficient capital within the ethnic-arts market of Quito. She seeks to break the bonds of domination and free herself and her family to live in modern Puyo and to enrich the town's expanding traditional and contemporary artistic life.

The strong image makers we have just described represent a much larger number of Canelos Quichua people who animate their culture through creative endeavors. If we were to explore the works of many more artists, we would find similar cultural underpinnings elaborated through individual experiences. Other artists whose creations have contributed significantly to this book and to the exhibition are Amadora Aranda, currently residing in Puyo, and her mother, Alicia Canelos, of Sarayacu; Santa Hualinga, of Sarayacu; Rebeca Hualinga, originally of Sarayacu but a long-time resident of Puyo; Alegría Canelos, of Curaray; Imitilia Hualinga, of Canelos; Rosaura Hualinga, of the Llushín River; the late Pastora Watatuca, of Unión Base; and many more. To a person, they have communicated the imagery richly embroidered in the tapestry of their cultural heritage across boundaries of time, space, and nationality.

¡Ama shua; ama llulla; ama quilla!
Don't steal; don't lie; don't be lazy!
This figure of speech, an ancient greeting within the Inca empire, is currently used as a statement of protest in Amazonian Ecuador. Working in Puyo, Rebeca Hualinga made a pottery jar symbolizing such a statement to sell in the ethnic-arts market; Amadora Aranda painted it.

¡Ama shua!
Don't steal!

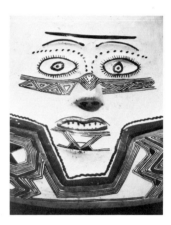

¡Ama llulla!
Don't lie!

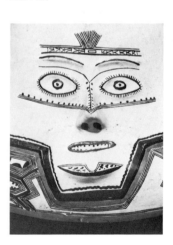

¡Ama quilla!
Don't be lazy!

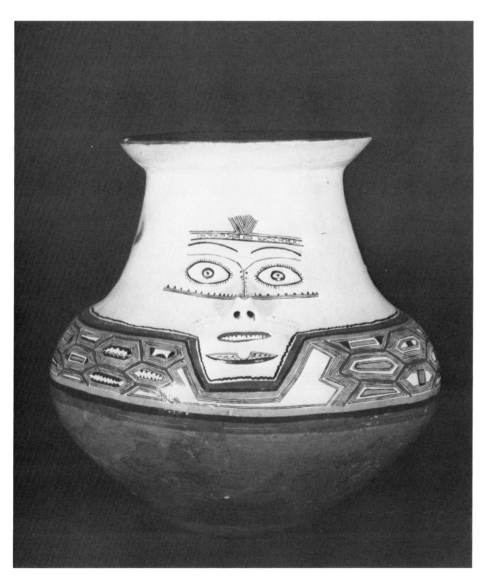

Recommended Readings and References Cited

Arnold, Dean E.
1985 *Ceramic Theory and Cultural Process.*
London: Cambridge University Press.

Babcock, Barbara, Guy Monthan, and Doris Monthan
1986 *The Pueblo Storyteller: Development of a Figurative Ceramic Tradition.* Tucson: University of Arizona Press.

Brodzky, Ann Trueblood, Rose Danesewich, and Nick Johnson (editors)
1977 *Stones, Bones and Skin: Ritual and Shamanic Art.* Toronto: Artscanada.

Carmichael, Elizabeth, Stephen Hugh-Jones, and Brian Moser and Donald Tayler
1985 *The Hidden Peoples of the Amazon.* London: British Museum Publications.

Carvajal, Gaspar de
1934 [1542] *The Discovery of the Amazon, According to the Account of Friar Gaspar de Carvajal and Other Documents.* Compiled by José Toribio Medina, edited by H. C. Heaton. Special Publication 17. New York: American Geographical Society.

Collier, Donald
1975 "Ancient Ecuador: Culture, Clay and Creativity, 3000-300 B.C." *Field Museum of Natural History Bulletin* 46 (4): 7-13.

Descola, Philippe
1986 *La Nature Domestique: Symbolisme et Praxis dans l'Écologie des Achuar.* Paris: Editions de la Maison des Sciences de l'Homme.

Eliade, Mircea
1964 [1951] *Shamanism: Archaic States of Ecstasy.* Princeton: Princeton University Press.

Fernandez, James W.
1977 "The Performance of Ritual Metaphors." In J. David Sapir and J. Christopher Crocker (editors), *The Social Use of Metaphor.* Philadelphia: University of Pennsylvania Press, pp. 100-131.

Furst, Peter T.
1977 "The Roots and Continuities of Shamanism." In Ann Trueblood Brodzky, Rose Danesewich, and Nick Johnson (editors), *Stones, Bones and Skin: Ritual and Shamanic Art.* Toronto: Artscanada, pp. 1-28.

Graburn, Nelson (editor)
1976 *Ethnic and Tourist Arts: Cultural Expressions from the Fourth World.* Berkeley: University of California Press.
1978 " 'I like things to look more different than that stuff did': An Experiment in Cross-Cultural Art Appreciation." In Michael Greenhalgh and Vincent Megaw (editors), *Art in Society: Studies in Style, Culture and Aesthetics.* New York: St. Martin's Press, pp. 51-70.

Helmore, Kristin
1984 "Museum Exhibits Native American Art." *Christian Science Monitor,* 27 September; reprinted in *News-Gazette* (Champaign, Ill.), 30 September.

Hemming, John
1978 *Red Gold: The Conquest of the Brazilian Indians.* Cambridge: Harvard University Press.

Hill, Jonathan (editor)
1988 *Rethinking History and Myth: Indigenous South American Perspectives on the Past.* Urbana: University of Illinois Press.

Kramer, Hilton
1982 "The High Art of Primitivism." *New York Times Magazine,* 24 January, pp. 18-19, 62.

Lathrap, Donald W., Donald Collier, and Helen Chandra
1975 *Ancient Ecuador: Culture, Clay, and Creativity, 3000-300 B.C.* Chicago: Field Museum of Natural History.

Linares, Olga
1977 *Art and Ecology in Ancient Panama.* Washington, D.C.: Dumbarton Oaks.

Marcos, Jorge (editor)
1986 *Arqueología de la Costa Ecuatoriana: Nuevos Enfoques.* Quito: Corporación Editora Nacional.

Matson, Frederick R. (editor)
1965 *Ceramics and Man.* Chicago: Aldine.

Métraux, Alfred
1927 "Migrations Historiques des Tupi-Guarani." *Journal de la Société des Américanistes* 19:1-45.

Myers, Norman
1984 *The Primary Source: Tropical Forests and Our Future.* New York: W. W. Norton.

Porras Garcés, Pedro
1987 *Investigaciones Arqueológicas de las Faldas de Sangay.* Quito: Impresión Artes Gráficas.

Price, Sally, and Richard Price
1980 *Afro-American Arts of the Suriname Rain Forest.* Los Angeles: Museum of Cultural History, University of California.